55°N

55°N

55 Degrees North
Contemporary Scandinavian Graphic Design

Patrick Sundqvist

Laurence King Publishing

THIS BOOK IS NOT

A HISTORICAL ACCOUNT of Scandinavian graphic design

A COMPLETE account of Scandinavian graphic design

A reflection of ALL work currently produced

THIS BOOK IS

A REFLECTION of current Scandinavian graphic design output

A STARTING POINT to discover more Scandinavian design

Hopefully, INSPIRATIONAL

Published in 2002 by
Laurence King Publishing Ltd

Copyright © 2002 Patrick Sundqvist

71 Great Russell Street
London WC1B 3BP
T. +44 20 7430 8850
F. +44 20 7430 8880
E. enquiries@laurenceking.co.uk
www.laurenceking.co.uk

A catalogue record for this book is available from the British Library.

ISBN 1 85669 316 3

Printed in Italy

Since it is impossible to know everything and everyone, the work in this book has been found through friends, friends of friends, by pure chance, luck, and perhaps, sometimes, by Divine intervention.

This book does not tell the whole story about Scandinavian graphic design, and nor is it the author's intention to do so. The book reflects contemporary Scandinavian graphic design, while also acknowledging that there is talent not represented here. Regardless, this book is a good starting point for further exploration.

For the purposes of this book, the term Scandinavia has been taken to include Sweden, Norway, Finland, Denmark and Iceland as this, though wrong, is the common international perception.

As a reference for reading the work credit texts throughout the book, **LP.** and **RP.** stands for left page and right page, respectively.

Scandinavia has a worldwide reputation for design. Some of the most revered practitioners in furniture, architecture and industrial design such as Arne Jacobsen, Alvar Aalto and Verner Panton hail from the region, imbuing it with a rich design heritage. Until recently, however, its graphics tradition had failed to garner an international following to the same degree. This disparity is now being addressed through the work of a new wave of practitioners, armed for the first time with the means to put their work in front of a global audience.

The region has a high standard of living with a well-educated population and is home to many world-famous brands: all factors important in sustaining a flourishing graphic design industry. It is only in the last ten to fifteen years, however, that the American or British model of the specialist graphic design studio has been adopted to any great extent. Previously, graphic designers were typically to be found within the art departments of publishing houses or working in advertising agencies, and as such were perhaps not as appreciated as their peers elsewhere.

Language has become less of a barrier now that younger generations speak English widely. Traditional patrons of innovative design, the music business and the fashion industry, are strong in the region, driving demand for new talent and providing an internationally visible outlet for that talent. Music is one of the top three export industries in Sweden, for example, while Scandinavian fashion brands such as Tiger and H&M are familiar names throughout Europe.

Wallpaper* magazine has also done much to promote its view of a particular Scandinavian design aesthetic to an international audience, not just in

There is a duality in the Scandinavian mentality that embraces both the maintenance and reverence of tradition, and the encouragement of modern ideas and technologies. Folk art, music and decorative styles remain vital and popular, but through improved communications Scandinavians are now more than ever visually integrated into a larger European consciousness.

its editorial coverage but also through commissioning many Scandinavian illustrators, photographers and art directors. The London creative department of Wink, the Wallpaper* branding agency spin-off, is almost entirely staffed by Scandinavians.

However, it is advances in technology, more than any other factor, that have played the major role in propelling Scandinavian graphic design from local to international prominence. There is a duality in the Scandinavian mentality that embraces both the maintenance and reverence of tradition, and the encouragement of modern ideas and technologies. Folk art, music and decorative styles remain vital and popular, but through improved communications Scandinavians are now more than ever visually integrated into a larger European consciousness. Scandinavia is home to two of the world's leading mobile phone companies, Nokia from Finland and Ericsson from Sweden, while the percentage of Scandinavians connected to the internet is the highest in Europe.

Thanks to this openness to technology, underpinned by relatively high levels of public spending in education and infrastructure, many Scandinavian children learn how to design a website at school. At college level, the region's enthusiasm for digital media is illustrated by the presence of specialist schools such as Sweden's Hyper Island or Space Invaders in Denmark (now closed) which were set up specifically to teach new media courses. It is also worth noting that governments in the region have viewed the provision of a communications infrastructure as a public rather than, as is the case in other countries, a private venture, thus ensuring a wider coverage. While third-generation mobile phone licences in Britain were sold to the highest bidder, the Swedish government made no charge on the

condition that operators promised to build a network that would reach the entire population. A low-density population scattered over vast areas means that in Scandinavia a mobile phone is often a necessity rather than an accessory. A population that has traditionally been isolated, both within its own countries and from the rest of the world, is now connected 24 hours a day.

The internet has allowed Scandinavian designers to circumvent problems of distance and isolation from their peers as it has in other societies. They may now work in networks and create communities based on shared interest rather than shared location. Just as importantly, the internet means that they are finally able to distribute their works at relatively low cost to a much larger audience, both in terms of interactive work and by using the web to showcase print projects. Thus, Scandinavian graphic design has come to the attention of the world at large.

Today Scandinavia is a relatively wealthy region and its young people have as wide an array of career opportunities available to them as their contemporaries in any other industrialized nation. The communications revolution has made media one of the most fashionable industries to work in, with web designer in particular being seen as almost as enviable an occupation as pop star or TV personality.

Allied to its fashionability, some aspects of web design would appear to be suited to the Scandinavian mentality. The isolation in Scandinavia has traditionally given rise to a practical, "do it yourself" attitude, since help or knowledge may have been far away. This attitude has also been driven by the economic realities of a society that was largely rural and relatively poor

until the early twentieth century, and is manifested today in the pride that many people take in building or renovating their own homes or summer houses rather than paying for someone to do it for them. It is strangely apposite for web design in terms of the opportunities that the medium provides for self-publishing, for building one's own little piece of cyberspace and using these personal pages as a classroom.

The web's accessibility means that reputations are established far quicker than in other media. The large numbers of Scandinavians creating experimental work online, often with a vibrant, playful edge, has meant that many of them have now become renowned figures in this area, whether actively seeking such "fame" or not. One of the most highly regarded and heavily used design community sites, K10k, is run by Danes – no print publication from the region has anywhere near as much international influence – while the popular netbabyworld comes courtesy of Swedish ACNE.

But Scandinavian graphic design is not restricted to the web. In common with their contemporaries elsewhere, Scandinavian designers use the computer to create in a variety of media. ACNE, for example, though now a fairly large company with many specialists, has always based its approach on plurality, designing for both the web and print, while also producing film, advertising and clothing. This multi-disciplinary approach is especially prevalent in Scandinavia, partly because of the "do it yourself" attitude discussed above and partly because budgets tend to be small in comparison to those of larger markets. In a more specialized area, Norway's Kim Hiorthøy has become an internationally renowned illustrator. Here too technology plays a part, enabling practitioners to work for an international client base without having to leave the region.

Look through the work displayed in this book and you will see a great variety of styles and approaches, some of which could as easily hail from any country, having assimilated the aesthetic and conceptual concerns prevalent in contemporary world graphic design. An examination of the work reveals a huge array of different sensibilities at work, none of which have any relation to the nationality of the designers concerned.

Take the pixel-based style of Cuban Council and Kingsize, for example. Cuban Council are Michael Schmidt and Toke Nygaard, who with Per Jørgen Jørgensen form the team behind K10k. Their Moodstats application is a kind of visual digital diary of how one's feelings change during any given day. Users can post their experiences up on the Moodstats site and compare them with others' globally. Kingsize have two illustrations in the book: one was made for print and the other was adapted for a music video, but both use a screen-based approach that has grown out of an affinity for old computer games and the restrictions of working on the web. Their work is part of an international aesthetic that includes the likes of eBoy in Germany and Englishman Craig Robinson's Flipflopflyin site among others.

Then there is the "future metamorphic" style of Jens Karlsson and James Widegren which internationally has come to be associated with The Attik in particular. This style has evolved as a result of computer-based digital

The internet has allowed Scandinavian designers to circumvent problems of distance and isolation from their peers as it has in other societies. They may now work in networks and create communities based on shared interest rather than shared location.

explorations with an emphasis on the functionality of Photoshop. The final designs often reference science, science fiction and futurism, with a keen interest in three-dimensional organic shapes and architectural structures.

Also taking a 3D, heavily computer-driven theme are the characters created by Klaus Haapeniemi, Anders Schroeder and Jarkko Ojanen. Japanese influences such as the Transformer toys and Manga are at work here, just as they are in the work of British studio Me Company, although the results vary enormously.

In contrast to this very futuristic, techno work, however, there is a more prevalent, traditional, crafts-based aesthetic producing beautiful, textural print work: for example, Fellow Designers from Stockholm or Gunnar Thor Vilhjalmsson from Reykjavik. These aesthetic groupings, moreover, are not distinct, with designers often switching styles rather than remaining exclusively in one camp or another.

Intellectually, Scandinavian designers are part of an international community that, through the web, allows designers everywhere to be connected. Ideas and styles are exchanged through community sites such as K10k and THREEOH as much as they are through physical encounters, making it far less likely that a particular approach would be found solely in a particular location. Considering this, is there, then, a distinctive Scandinavian style or sensibility?

Think of Scandinavia and the clichés come flooding in: the fjords, the snow, the forests and mountains, the flat-pack furniture. Such clichés can also be applied to the region's design output. Adjectives such as clean,

simple and bright recurred when designers featured in this book were asked for their definition of Scandinavian graphics ("Clean air means clean design" was a comment that occurred more than once) but, as is obvious from even a cursory glance at the book's content, and from the discussion above, that is an oversimplification.

When the rest of the world refers to "Scandinavian" design, they often have Denmark, Finland and Sweden in mind as these three have the biggest design industries, but there are differences in approach between all the countries in the region. In so much as it is possible to highlight distinguishing characteristics, it is graphic design from Denmark and Sweden that has earnt the region its reputation for cleanliness and simplicity compared to Norway, for example, where work may sometimes be more colourful and less restrained typographically. Thanks to its strong fashion and music industries, Sweden tends to be a little more cutting edge, whereas Denmark produces a lot of serious branding work. Finland, however, must be seen as an entirely different entity – it is not part of Scandinavia proper and has a very different language. Occasionally the Finnish trait known as Sisu may surface in the work as a rougher, more Punk aesthetic. Iceland is very different again with a wide variety of styles and a design industry that often looks to the US for references as the island is situated between Europe and North America where many Icelanders are educated.

How far those aspects of culture and environment that are common to the region as a whole influence the output of its designers is open to question, but it is worth outlining some of the shared regional factors which inform their experience.

Being on the fringes of the world has meant that Scandinavians have traditionally been keen travellers. Many Scandinavian designers now work abroad, but as well as exporting personnel, Scandinavia has also been eager to import foreign cultural influences, out of curiosity or a desire to remain competitive and to feel better connected to the rest of the world. Most modern design movements have been assimilated into the Scandinavian design consciousness as they have elsewhere, but perhaps the Bauhaus has been particularly influential as its preaching of form following function is sympathetic with long-held Scandinavian ideals. The region's strongly Protestant tradition produces a preference for clean, functional design in contrast to the highly decorative styles of Catholic southern Europe (although this was also necessitated by the poverty which afflicted the region until the twentieth century, especially in comparison to the wealth of Spain or Renaissance Italian city states).

The Lutheran approach to life also dictates that one cannot be too loud or too aggressive in one's approach. This is embodied in the concept of Jantelagen (or law of Jante) whereby citizens are reminded that they are no different or more important than the rest of the population, irrespective of social position, wealth or success. Mainly prevalent in Denmark and Sweden, it's a kind of antidote to hubris which perhaps does not sit well with the concept of the "superstar designer". The relentless self-publicizing that goes with the establishment of a major international reputation in graphic design through magazine interviews, lectures, entering awards and the publication of monographs may be seen to be firmly at odds with a society raised on the understanding that "successful" does not equal "better". Its egalitarian principles, which have been at the heart of Scandinavian socio-political development since the Second World War, may also be one of the reasons why so many community websites, such as K10k, come out of the region.

The harsh climate has led to the development of the Scandinavian home as a comfortable refuge. It has been argued by some that this is a significant factor in the Scandinavian love of good design – that spending so much time in the house produces a desire to make that house and everything in it as beautiful and well-made as possible. Perhaps the climate itself influences visual styles – for Stefan Kjartansson of Armchair Media "Snow is modernism in its purest form". The climate also helps produce a common traditional colour palette that can surface in design work. Light materials are used frequently which is understandable since not only are they naturaly occurring (pine, spruce, etc.), they brighten up an otherwise dark winter. But other factors are more esoteric: in Sweden almost all old houses were painted red with white trimming, and summer homes are still usually painted this way. This had nothing to do with the fact that Swedish people loved red, but rather that the pigment was a leftover product from copper mining making red the cheapest colour paint to use.

Against these traditional factors, however, we must balance the fact that most Scandinavian graphic designers live in cities, watch MTV and are as absorbed in the global brand culture as designers from any other industrialized nations, perhaps more so given their historical vantage point from the margins. Scandinavian graphic designers' influences are as likely to have come from the latest movements in contemporary culture, as they are to have come from the pine forests or the midnight sun.

Ultimately, Scandinavian graphic designers should be viewed in the context of an international design community, aligned more closely on aesthetic grounds than those of nationality. They are citizens of a design world in which local factors have become overridden by common influences. There are certain factors and certain determinants within the region which have informed the development of the industry and of those who work in it and which may exert a latent influence on the work produced, but they are not all-pervasive enough to be extrapolated into a definition of a specific "Scandinavian Style".

At first it may be depressing to think that the graphic design output of as geographically distinct a region as Scandinavia has subsumed local characteristics in favour of internationalism. It would be foolish, however, to

assume that graphic design is immune from a phenomenon that has touched every aspect of human society. And globalization has benefits in that it has allowed Scandinavia's designers to be integrated into the international grahic design community and to be judged on equal terms with their peers from other countries.

The Scandinavian experience is mirrored elsewhere as, helped considerably by digital communications networks, graphic design becomes a genuinely international industry with talent rather than location being the decisive factor for success. Through these networks and the talent of its practitioners, Scandinavian graphic design has come to global prominence as never before.

Community design sites, entirely or partially created by Scandinavians, can be found at the addresses below

Kaliber 10 000
www.k10k.net

Surfstation
www.surfstation.lu

THREEOH
www.threeoh.com

Hyper Island & Space Invaders can be found at the addresses below

Hyper Island
www.hyperisland.se

Space Invaders
www.spaceinvaders.dk

WORK

Design Ricky Tillblad **LP.** Dixie Character development for use in various media
RP. Max
RP. Glenn

40U41BA

MAX 2/003
DIXIE™ COLLECTION SERIES
THREE FASCINATING SUBJECTS AVAILABLE
NET WT. 1¼ OZ.

GLENN 3/003
DIXIE™ COLLECTION SERIES
THREE FASCINATING SUBJECTS AVAILABLE
NET WT. 1¼ OZ.

MONGREL ASSOCIATES

Design Jarkko Ojanen

CLUB LABYRINTH FINLAND 2001

LP. Labyrinth Characters Illustrations for Labyrinth

SONERA 2001

RP. Sonera Characters Illustrations for Sonera m-Space

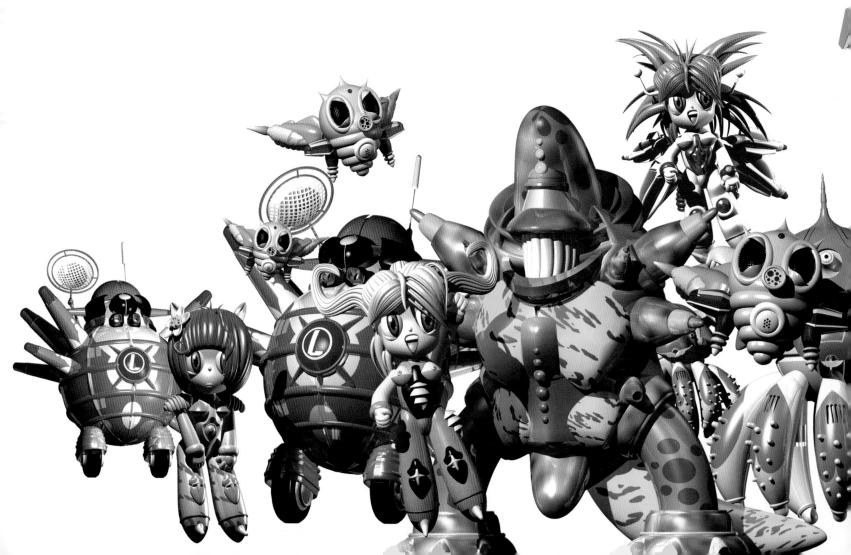

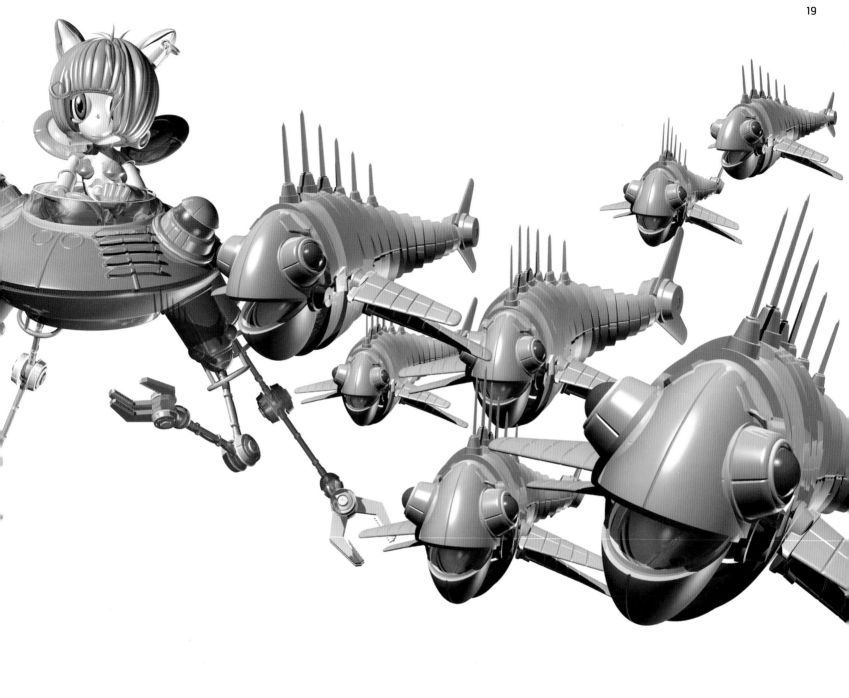

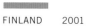

MONGREL ASSOCIATES SONERA FINLAND 2001

Design Jarkko Ojanen Sonera Characters Illustrations for Sonera m-Space

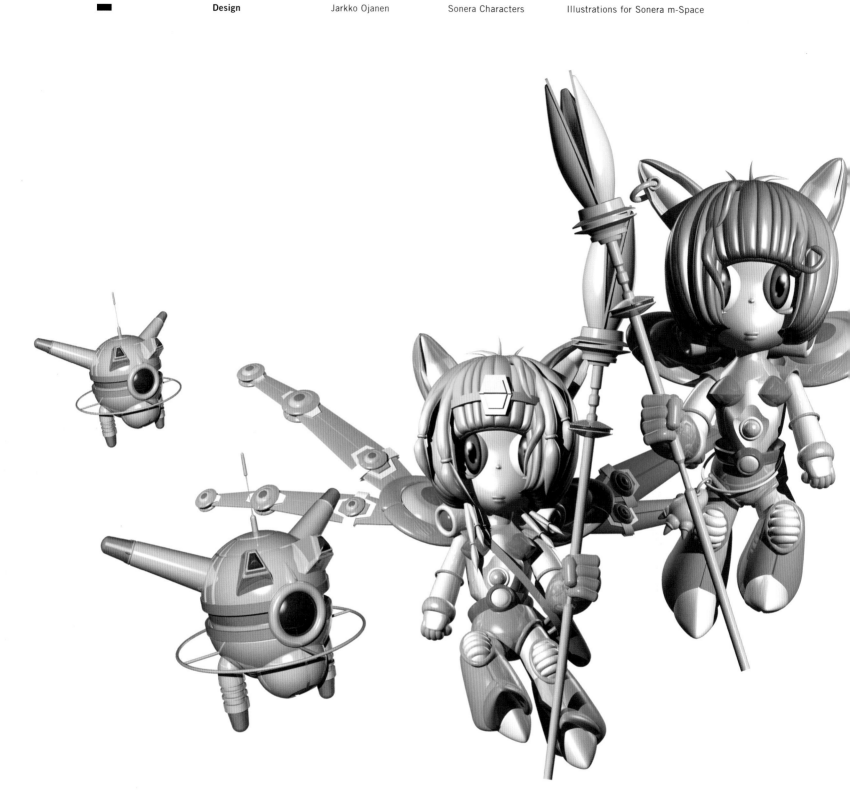

EIRIK SEU STOKKMO

TEIPU™ – PERSONAL PROJECT NORWAY 2001

Design Eirik Seu Stokkmo **LP**. Picnic Part of final project at NABA School of Design, Milan
RP. Radio

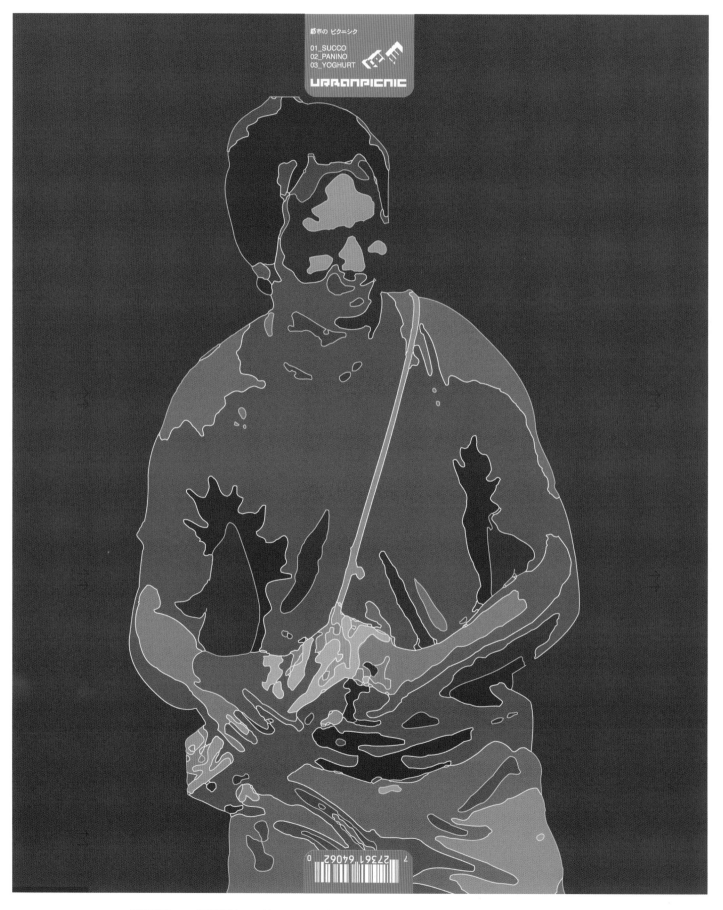

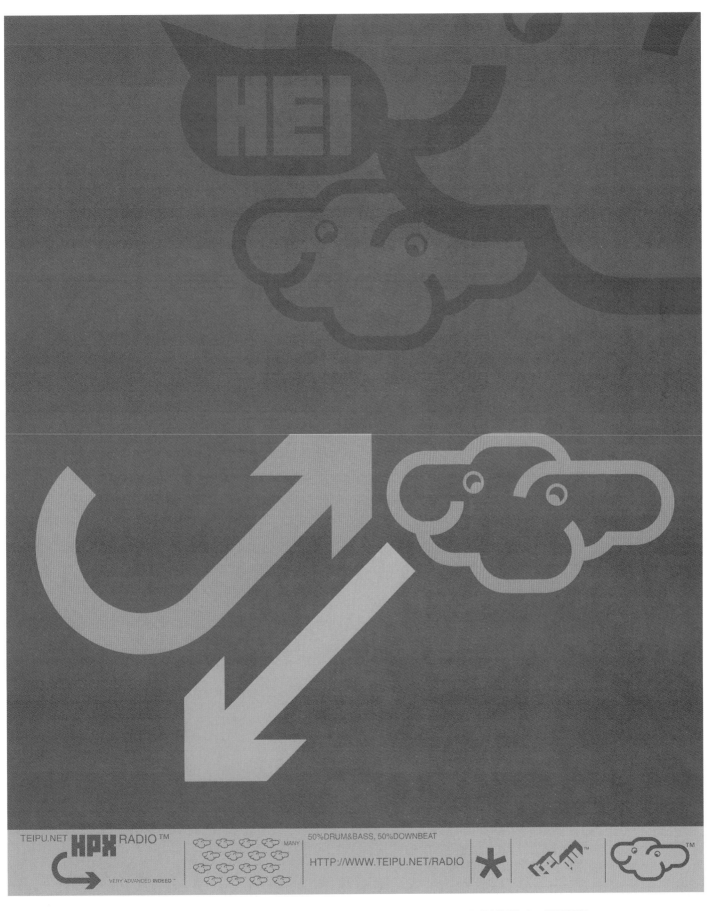

Design Eirik Seu Stokkmo Oslo Athletico Record sleeve for Oslo Athletico

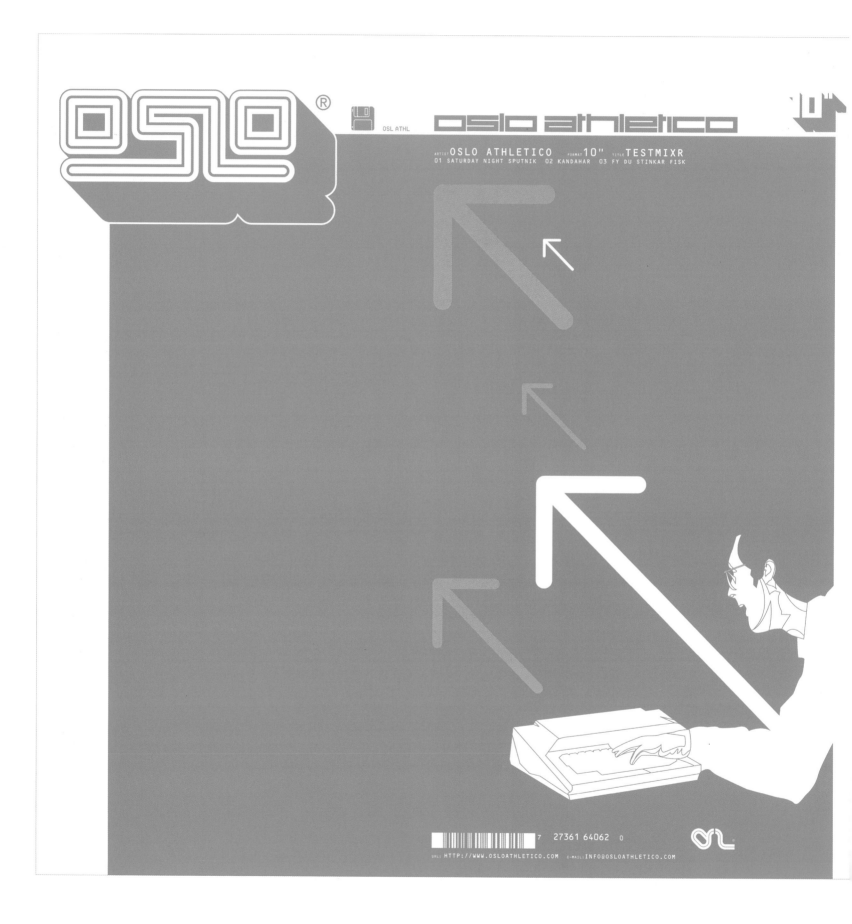

Design Martin Kvamme Black California Kaada CD front cover
Thank You for Giving Me Your Valuable Time Kaada flyers

Design Miika Saksi The Duplo Promotional poster
 The Duplo CD cover design

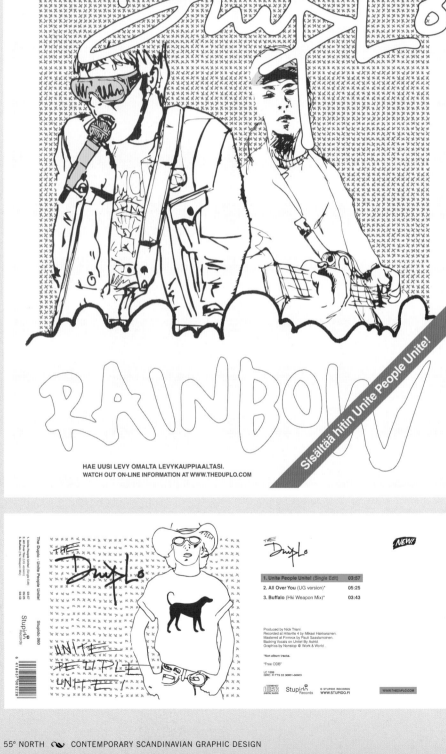

Design Ricky Tillblad Joia Record sleeve for Outfunk

Outfunk
Freshely Squesed
JOIA 001

All rights of the producer and the owner of the recorded
work reserved. Unauthorized coping, public
performance, broadcasting, hiring or rental of this
recording prohibited. Distributed by Intergroove.

Joia Records: Fryxellsgatan 13, 114 53
Stockholm, Sweden. Fax +46 8 653 35 60.
www.joiarecords.com

℗ & © 2001 Joia Records

joia®

JOIA 001
33 RPM
SIDE B

Design Martin Kvamme Flyer Love Flyer series The Unit Delta Plus

Friends Eat Together™

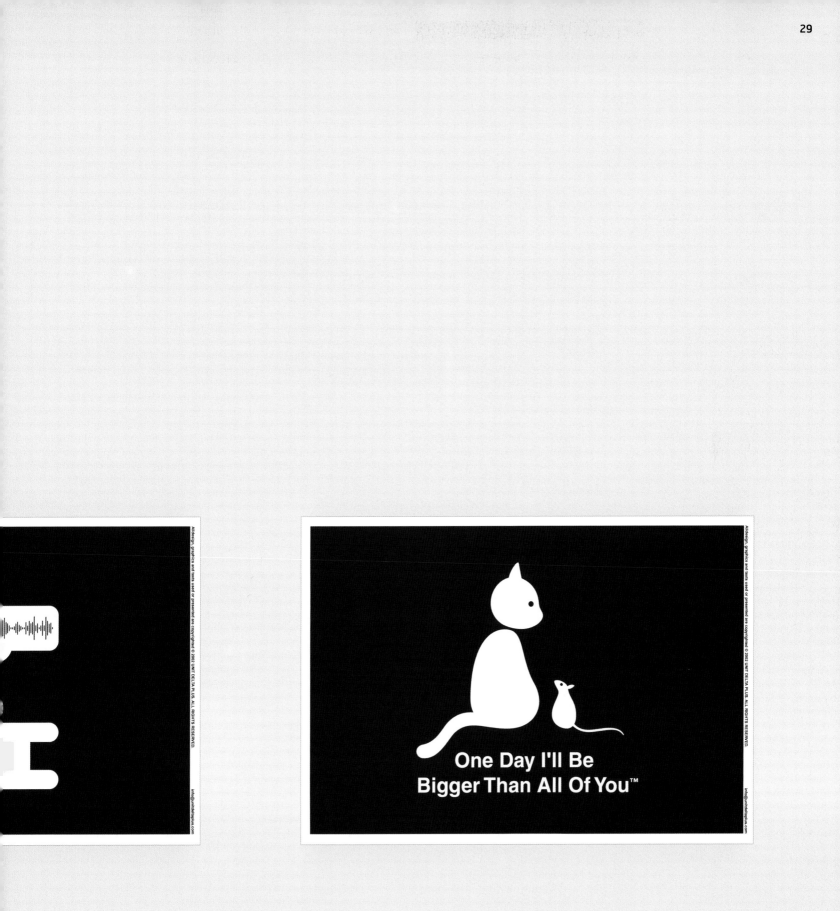

One Day I'll Be
Bigger Than All Of You™

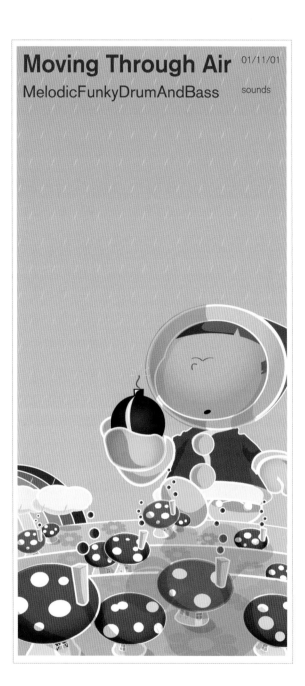

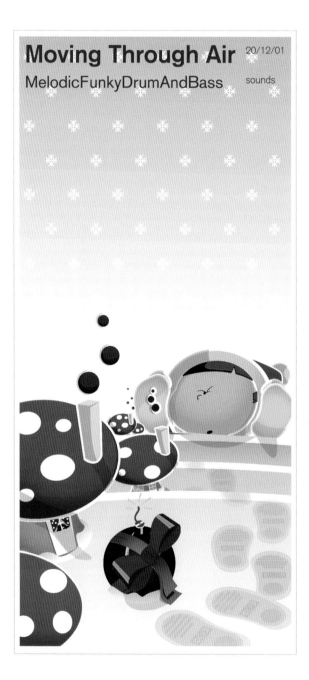

| **Design** | Kustaa Saksi | Moist | Club night flyers |
| **Illustration** | Hajime Sorayama | | |

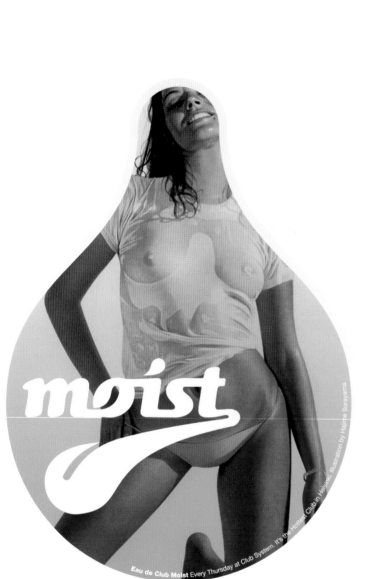

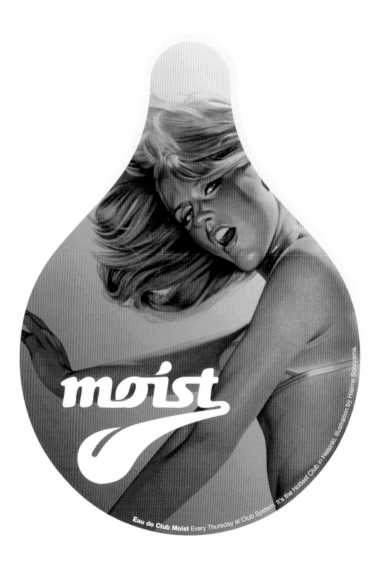

 Design Kim Hiorthøy Phanerothyme 12" record sleeve design

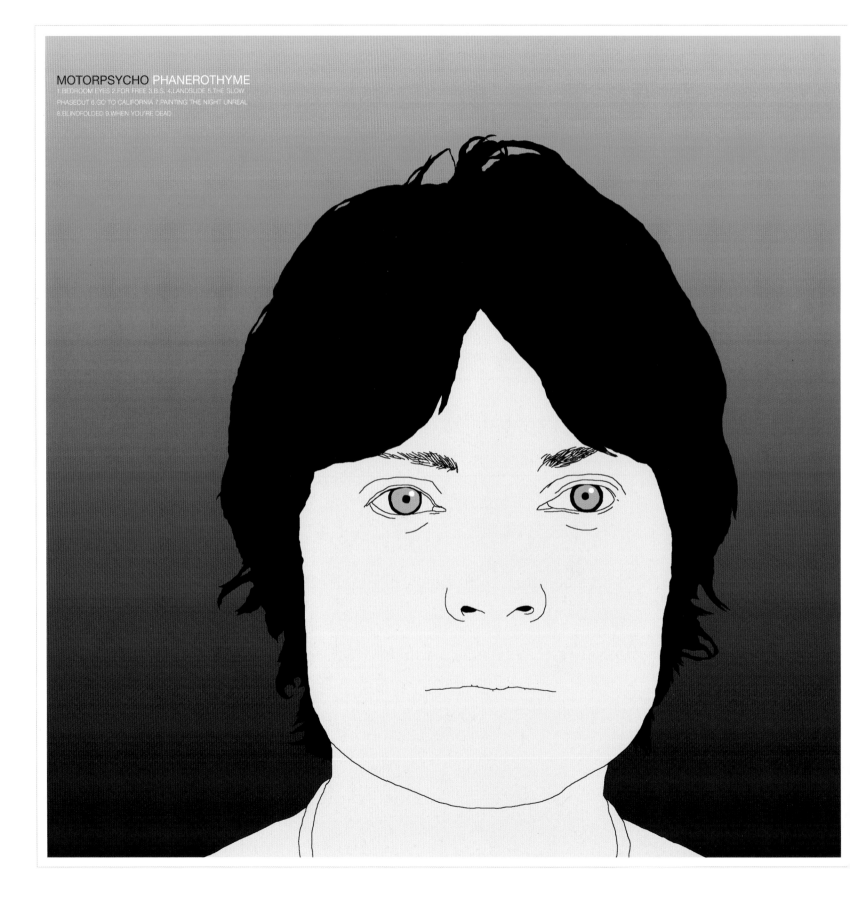

MOTORPSYCHO PHANEROTHYME
1.BEDROOM EYES 2.FOR FREE 3.B.S. 4.LANDSLIDE 5.THE SLOW
PHASEOUT 6.GO TO CALIFORNIA 7.PAINTING THE NIGHT UNREAL
8.BLINDFOLDED 9.WHEN YOU'RE DEAD

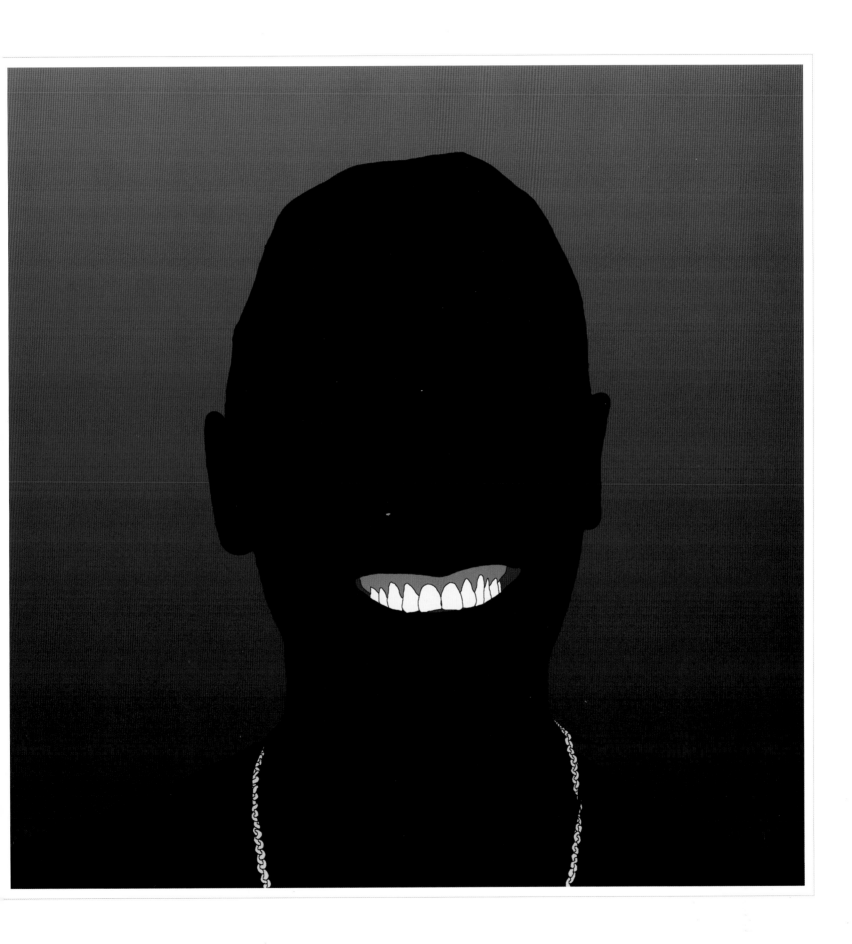

Illustration Sweden Green Island Magazine illustrations
Red Island

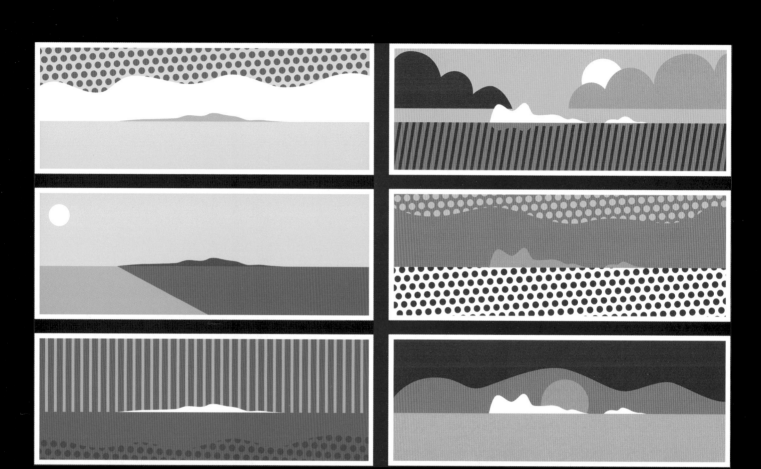

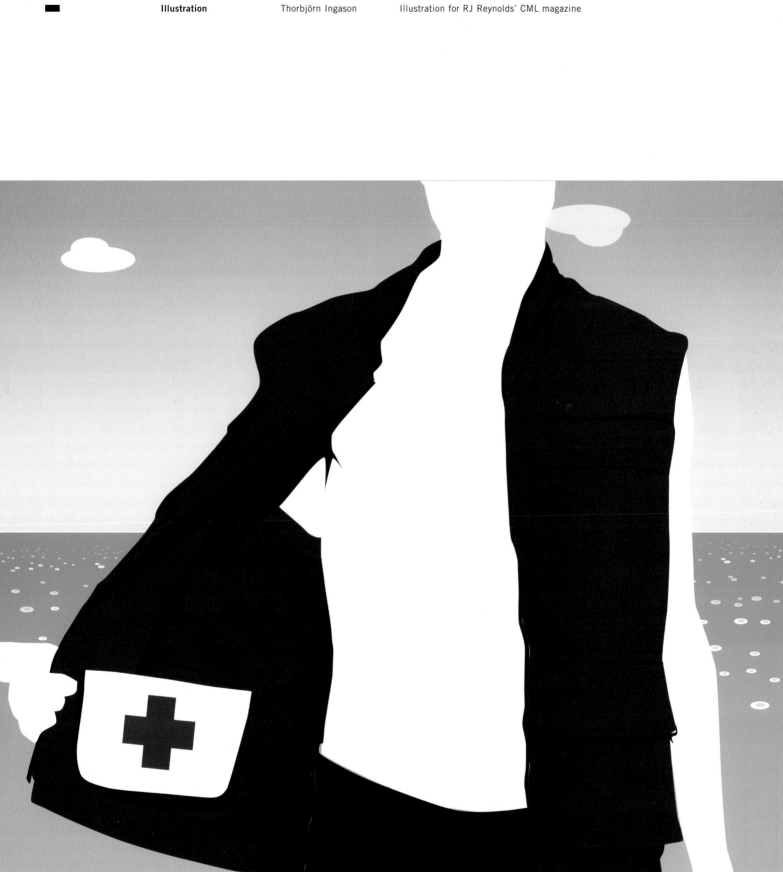

THOMAS BRODAHL **PERSONAL PROJECT** NORWAY 2001

■

Illustration Thomas Brodahl **LP.** My Adidas Illustrations, personal project
 RP. French's Mustard
 RP. Heinz Baked Beans

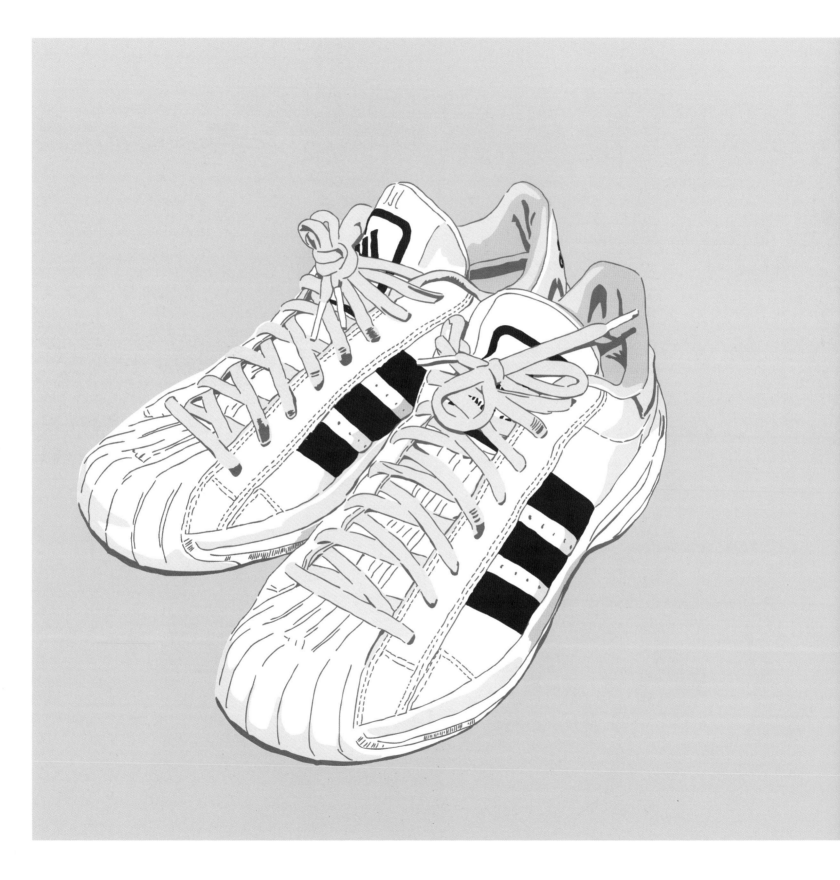

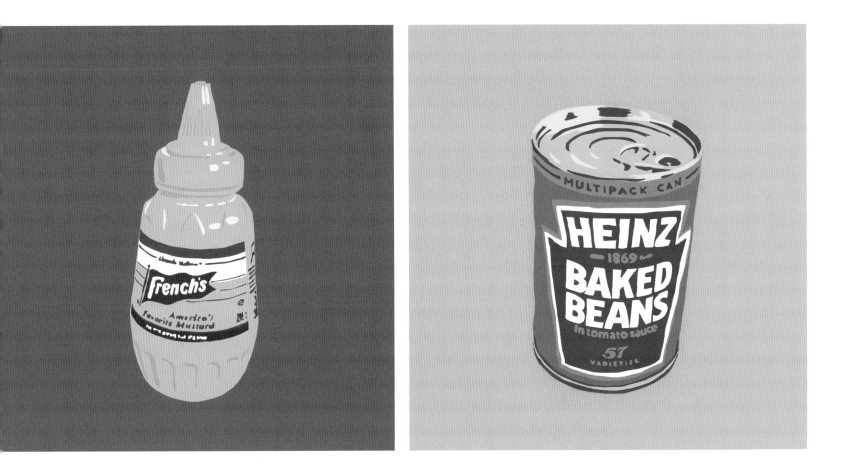

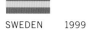

Design Sweden Friend – Sauna Sessions 12" record sleeve design

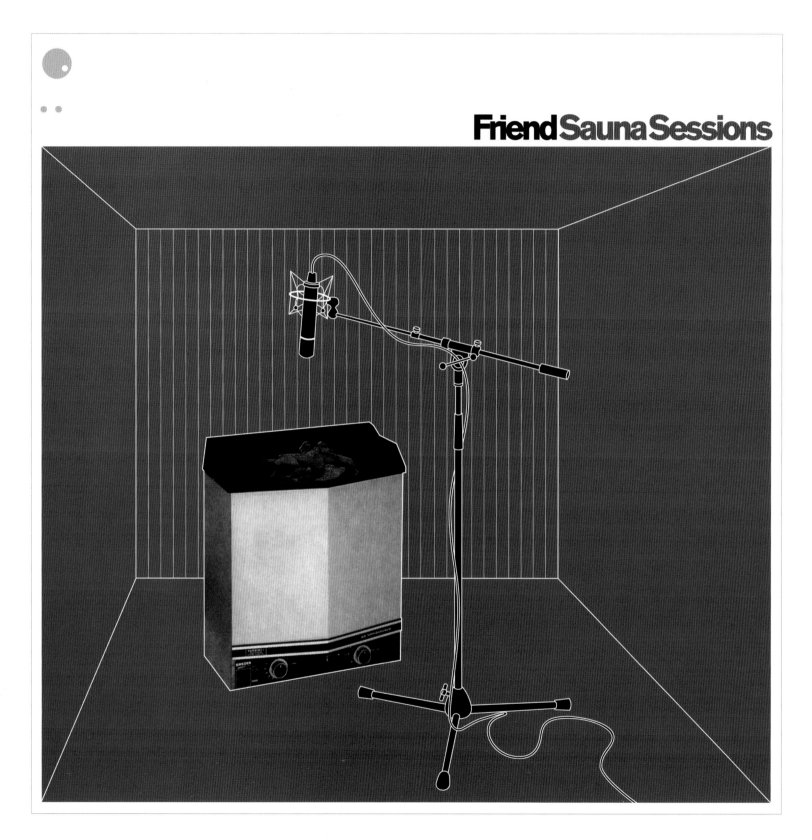

Design　　Alphabetical Order　　Wonderful World of Video　　Video commissioned by onedotzero for onedottv

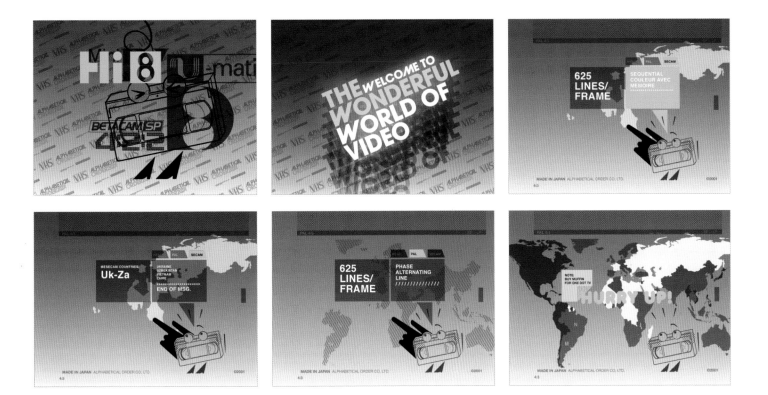

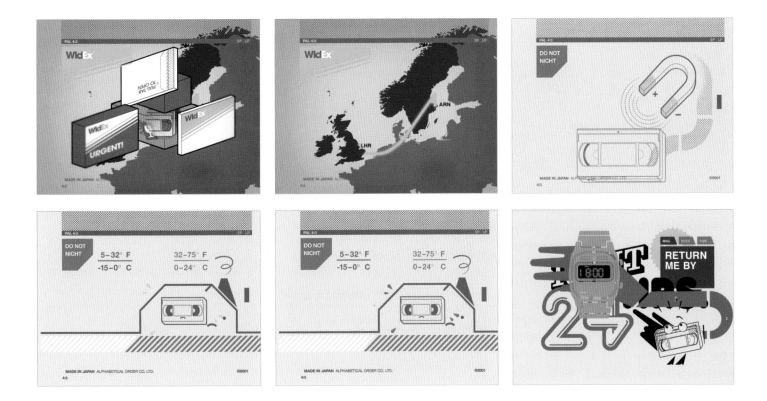

STADSTEATERN SWEDEN 1998 & 2000

Design Eva Liljefors LP. Rabarbers Posters for Backstage, Stadsteatern, Stockholm
 Paul Kühlhorn Baby Love

 LILJEVALCHS 2002

 RP. Vårsalongen Poster for the Spring Salon at Liljevalchs, Stockholm

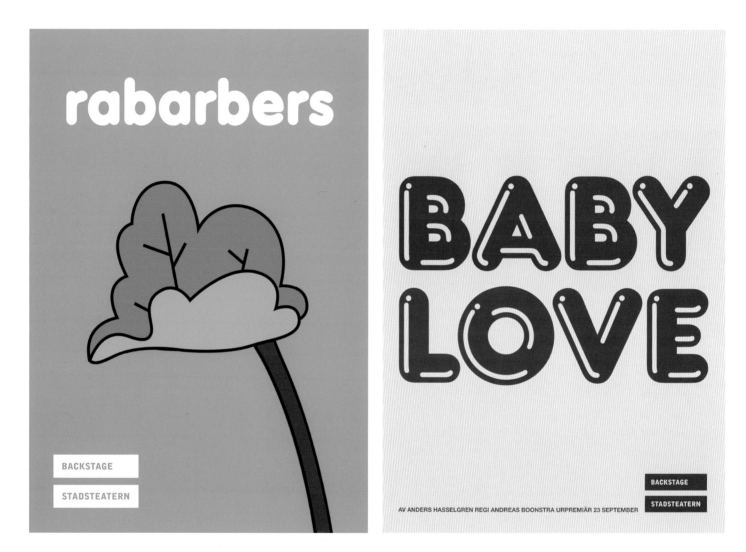

Vårsalongen Liljevalchs
25 januari – 17 mars 2002 tisdag – söndag

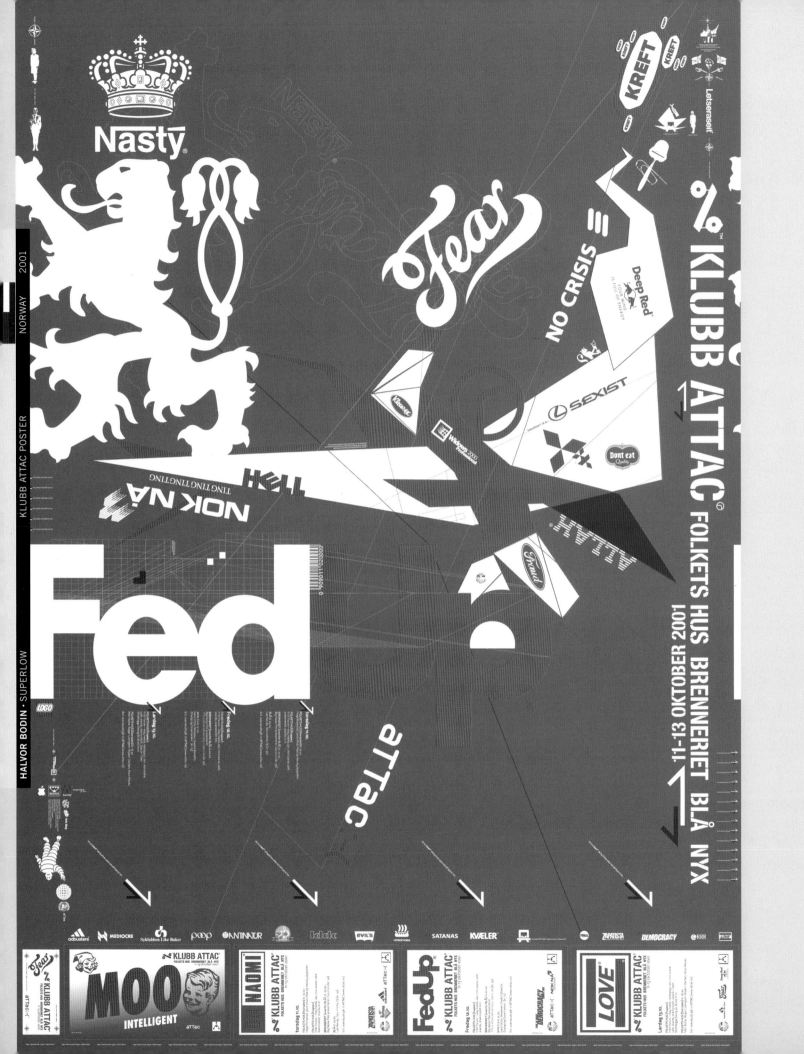

Design Kjell Ekhorn Watch For Tsunami When You Feel Earth Quake Limited edition promotional CD
Jon Forss

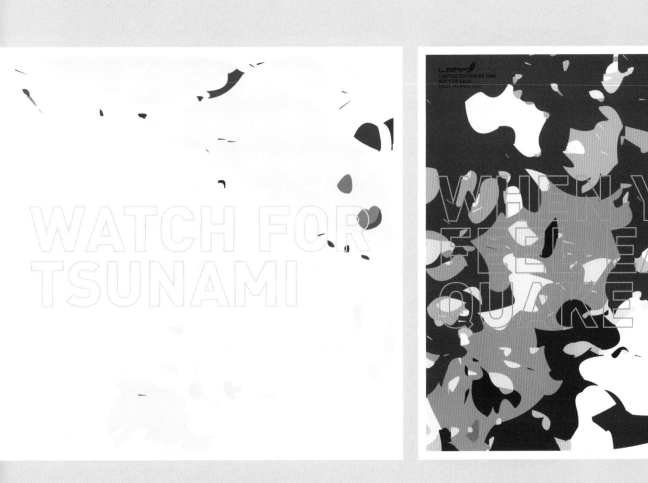

Design Nicolai Schaanning Larsen Oyster Student work, CD cover design

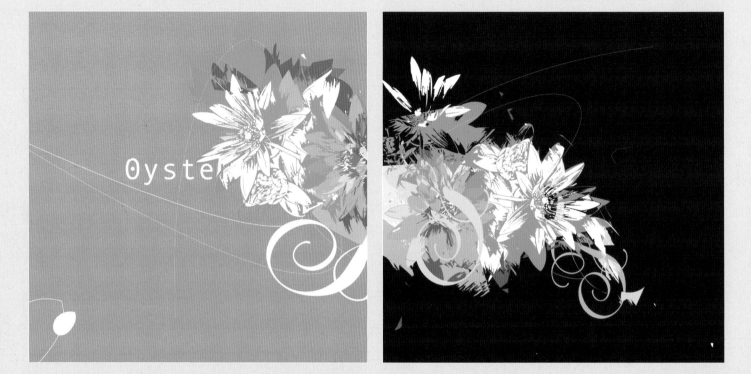

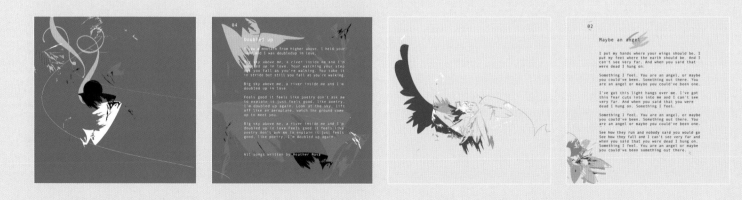

Design Kim Hiorthøy Hei CD cover design for artist Kim Hiorthøy
 Torture Happiness 7" cover design for artist Kim Hiorthøy

MONGREL ASSOCIATES

Design Kustaa Saksi Website for photographer Lauri Eriksson

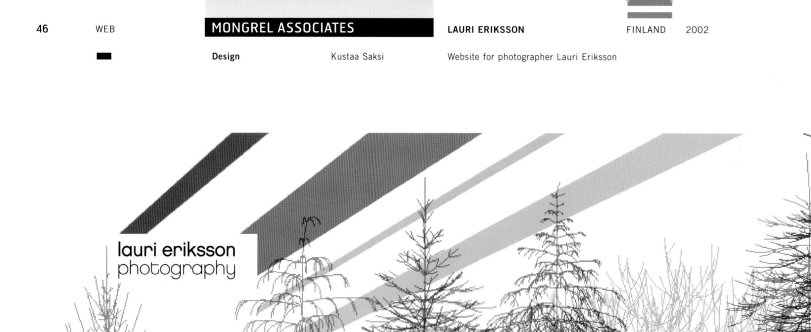

lauri eriksson
photography

loading..

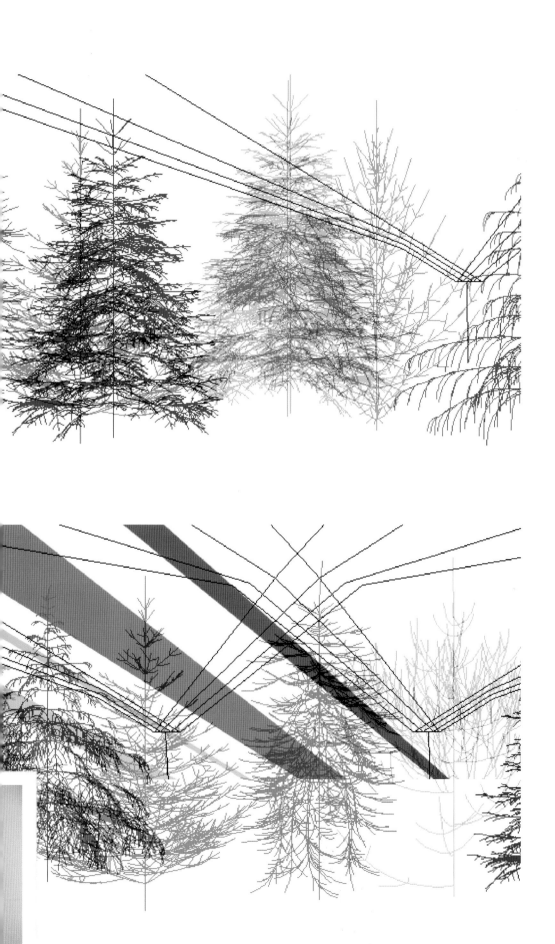

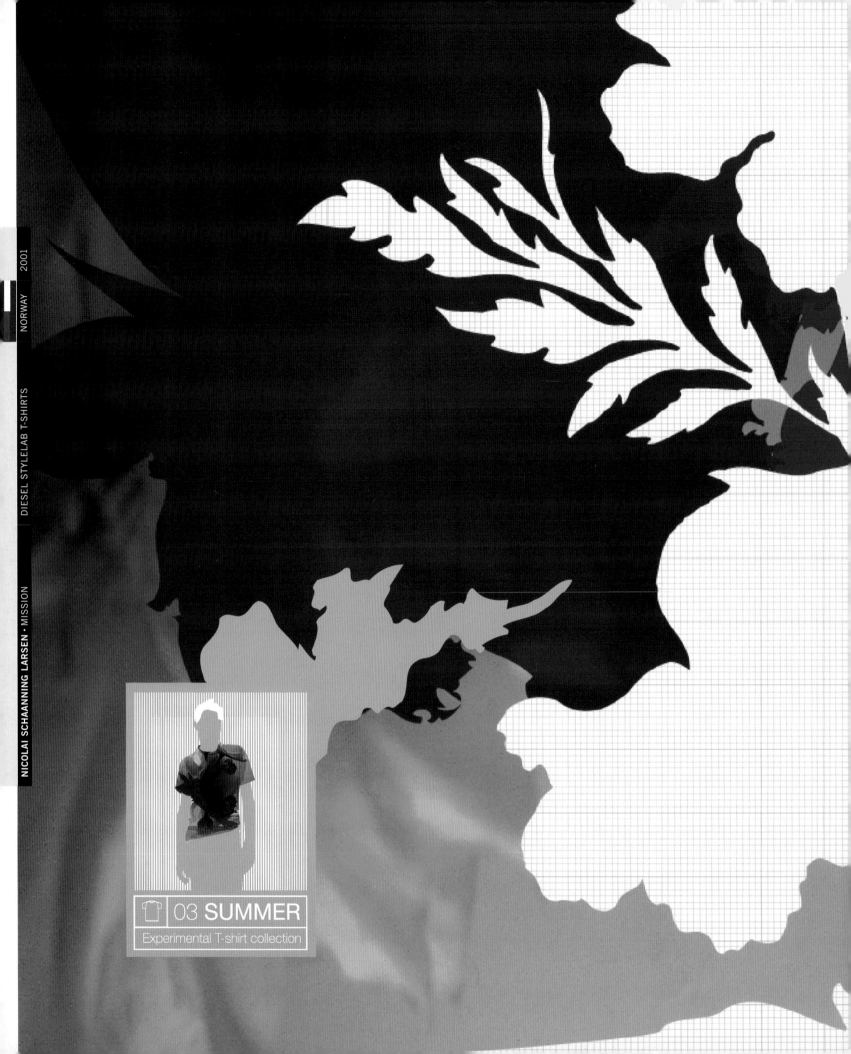

03 SUMMER
Experimental T-shirt collection

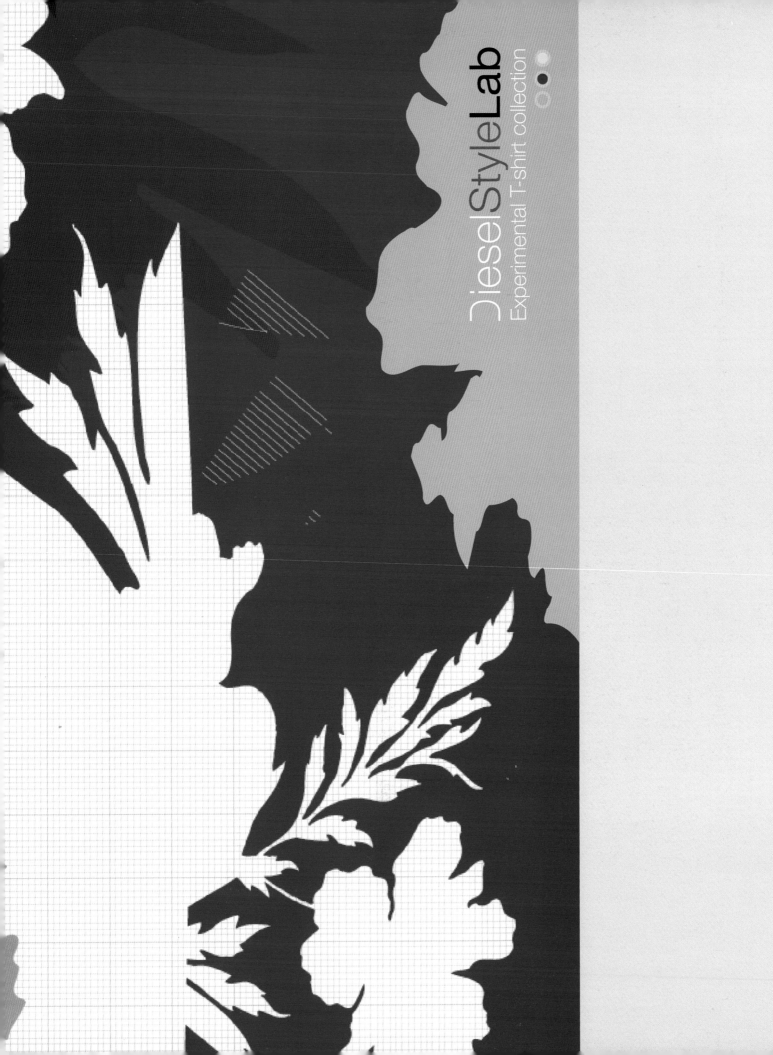

DieselStyleLab
Experimental T-shirt collection

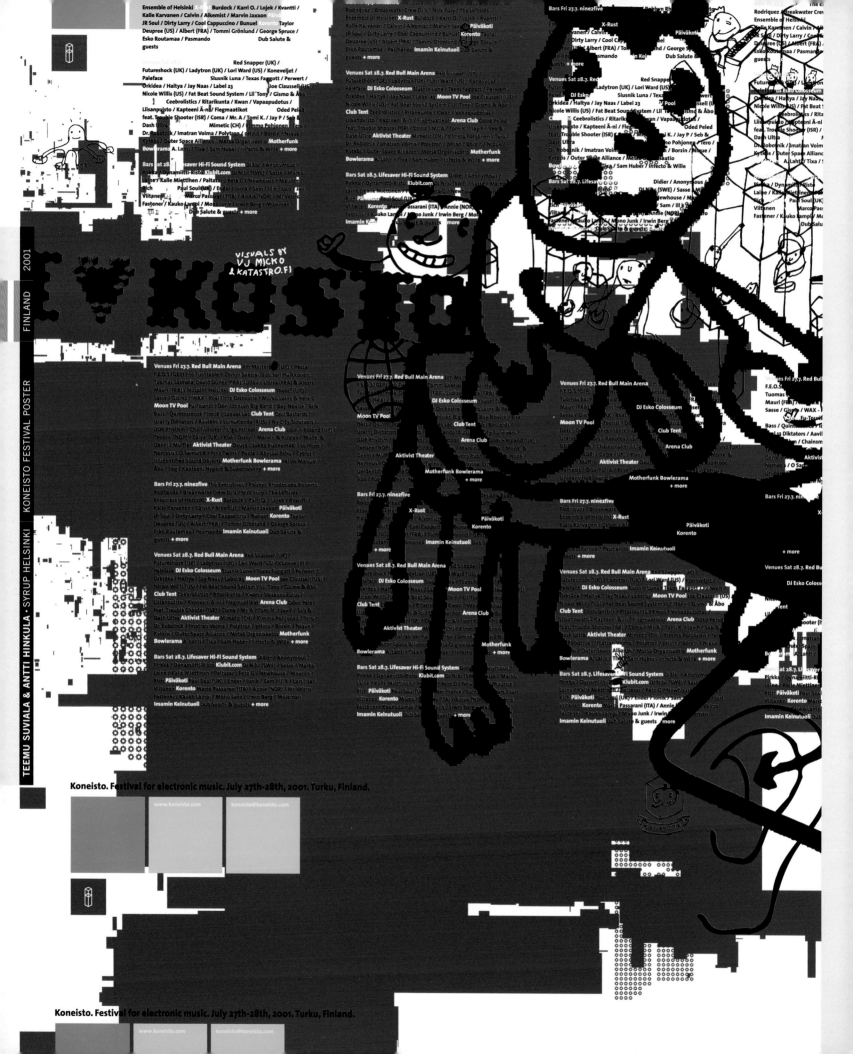

Design Kjell Ekhorn Invisible Soundtracks 12" record sleeve front and back cover
Jon Forss

Architectural Illustration Cornelia Fischer

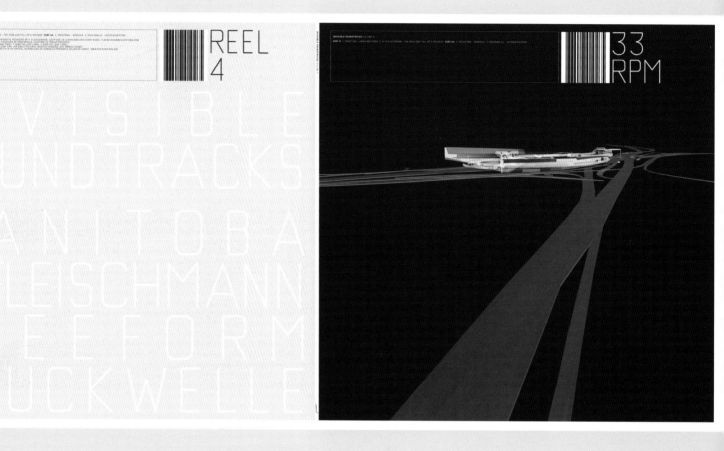

Design Kim Hiorthøy

Electric Label CD cover design for the artist Arne Nordheim
Nordheim Transformed CD cover design for the artists Biosphere / Deathprod

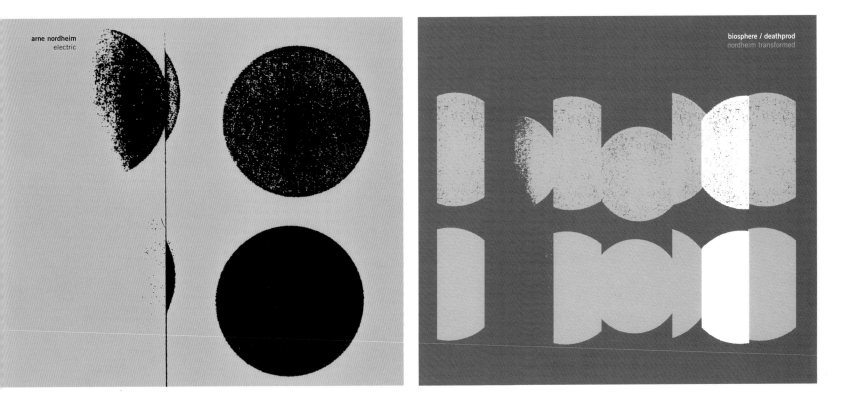

arne nordheim
electric

biosphere / deathprod
nordheim transformed

Design Tomi Friman **LP.** Control skateboard designs
 RP. Control skateboard T-shirt design

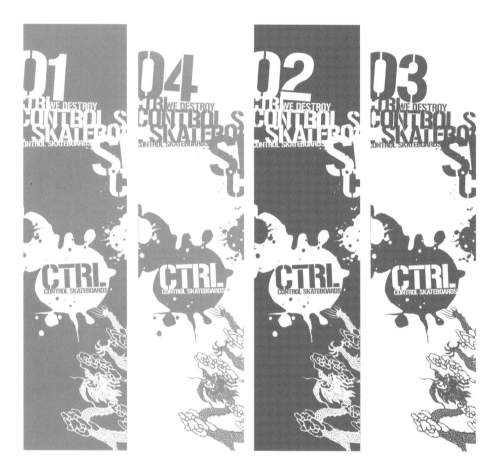

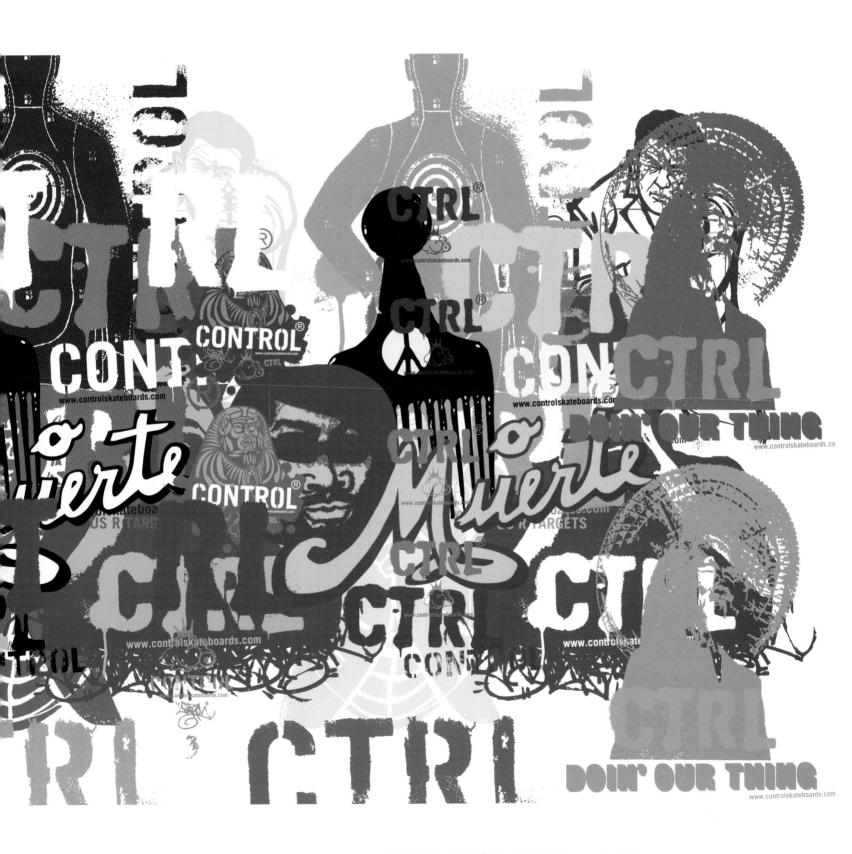

Design Ida Wessel Collage Collage of different client work

Design Martin Ström
Peter Ström

Pluxus European Onion CD front and back cover design

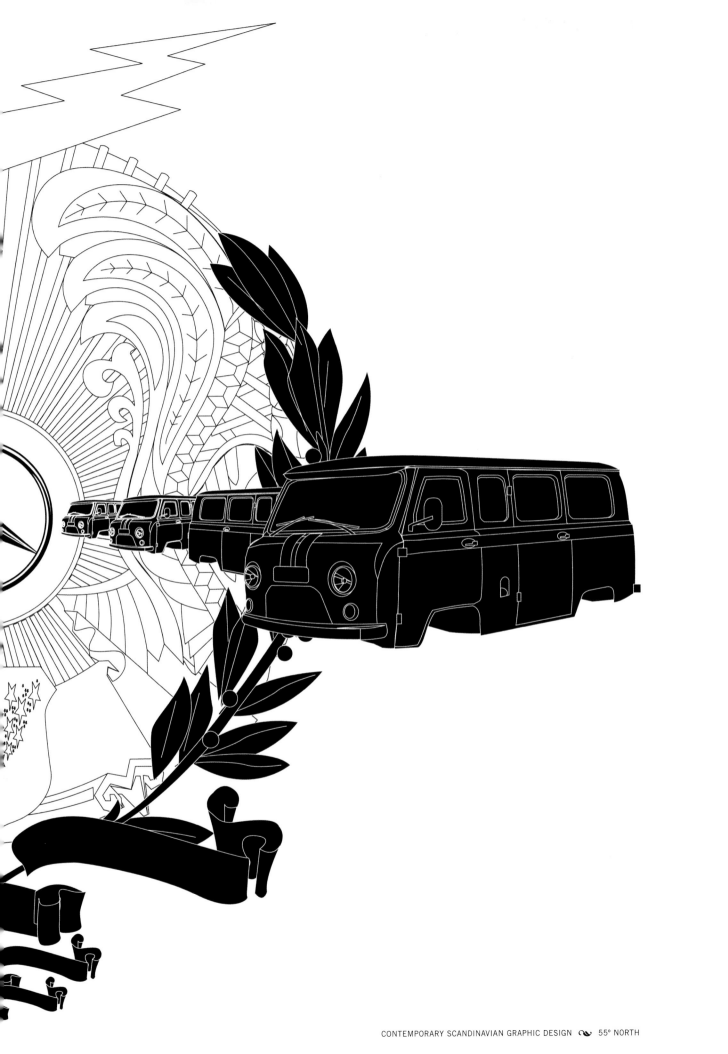

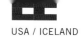

KARLSSONWILKER INC.

STUDIO BOYM USA / ICELAND 2001

Design	Hjalti Karlsson	The End Catalogue	Designs from The End catalogue
	Jan Wilker		
3D Modelling	In-House		

NEW
AND BY POPULAR DEMAND

THE END

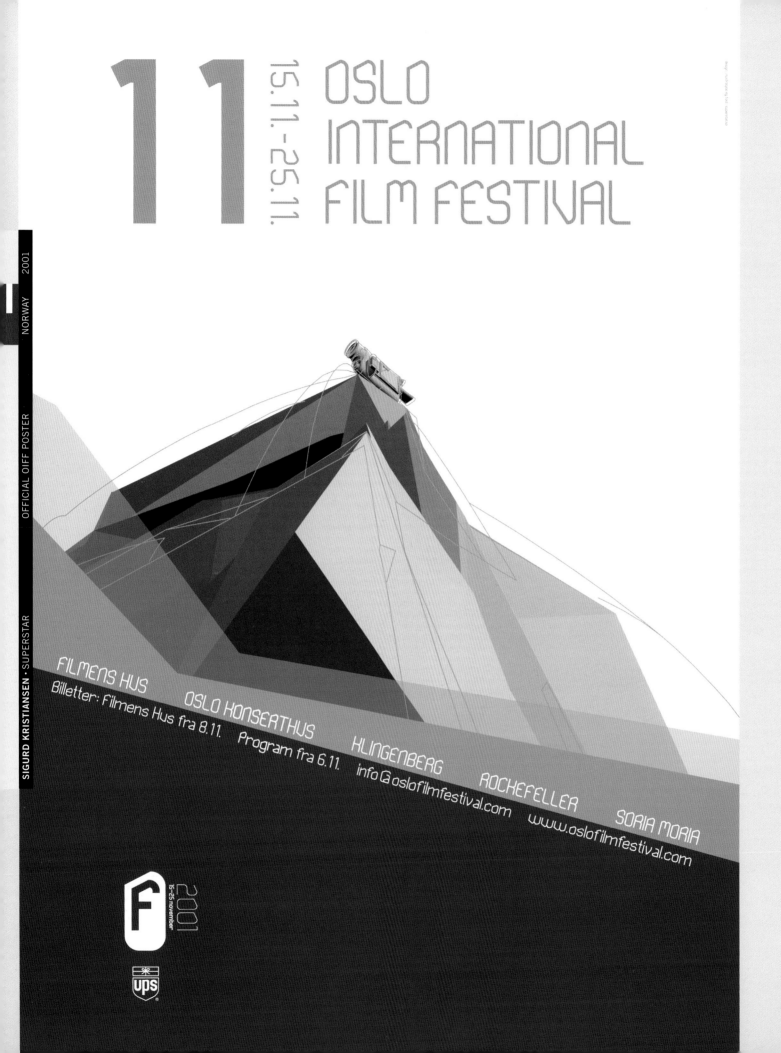

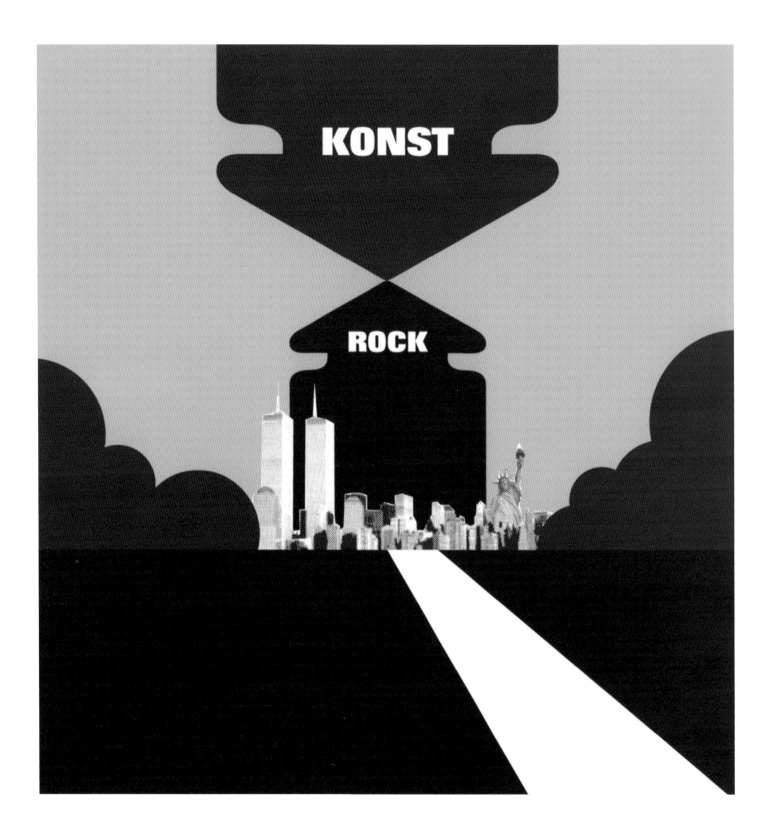

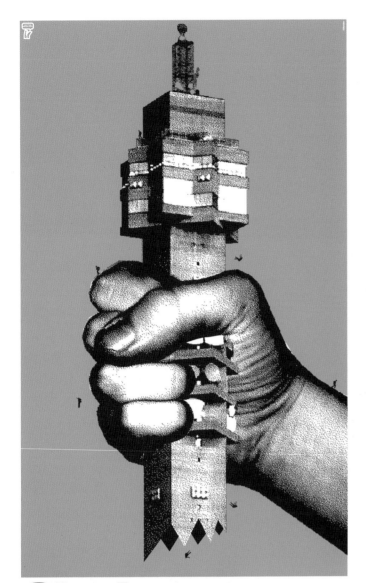

Skala 1:1

En improviserad helaftonsföreställning. Premiär 16 Februari

Med en berättarteknik, lik den i Robert Altmans film "Short Cuts", framförs korta sekvenser av historier som läggs samman till längre berättelser. Dessa bildar en helhet i full skala som pendlar mellan tid och rum, logik och fantasi, komedi och tragedi. I varje föreställning skapas helt nya historier och berättelser, karaktärer och öden – vilket gör varje kväll till en premiär.

Stockholms Improvisationsteater
Fredag–Lördag kl.19.00 Sigtunagatan 12, T-S:t Eriksplan

Biljetter och information
08-30 62 42
www.impro.a.se

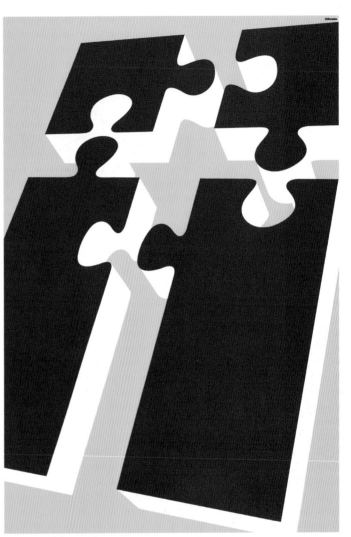

Skala 1:1

En improviserad helaftonsföreställning. Premiär 18 februari

Improvisationsformen i Skala 1:1 är inspirerad av den San Franciscobaserade improvisationsgruppen True Fiction Magazine. Små bitar av historier läggs samman till längre berättelser. Dessa bildar en helhet i full skala som pendlar mellan tid och rum, logik och fantasi, komedi och tragedi. Regina Saisi från True Fiction Magazine inledde med en tre veckor lång workshop varefter Roger Westberg tog över och slutförde repetitionsarbetet. Detta är grunden till en mer fördjupad och variationsrik improvisationsform där publiken lovas en ny händelserik föreställning varje kväll.

Stockholms Improvisationsteater
Torsdag–Lördag kl.19.00 Sigtunagatan 12, T-Odenplan

Biljetter och information
08-30 62 42
www.impro.a.se

MARKUS MOSTRÖM DESIGN ASTRID LINDGRENS BARNSJUKHUS SWEDEN 2001

Design Markus Moström Pippi-dagen Poster for the Pippi Day, anniversary celebrations, at Skansen,
 Anders Malmströmer Stockholm, for Astrid Lindgren's Children's Hospital
 Jonas Bergstrand

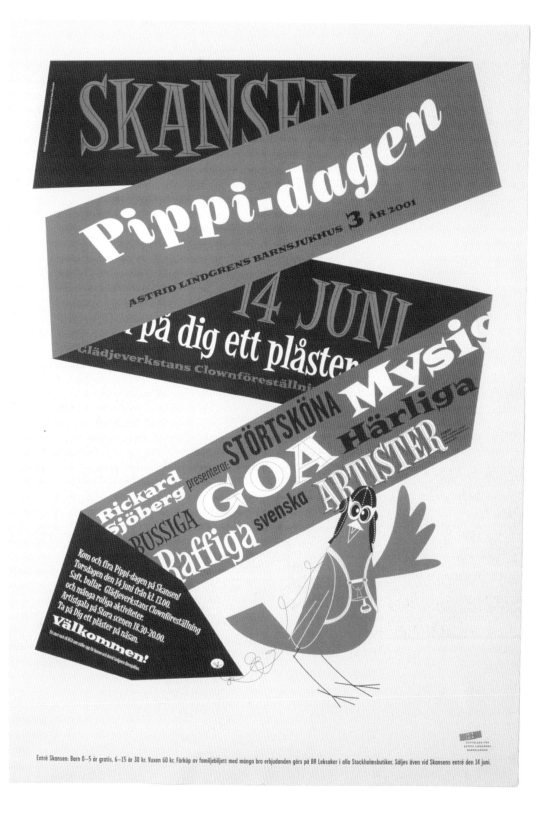

■ **Design** Teemu Suviala Don't Mind About The Villasukkas Jim & Jill, sale poster

Antti Hinkula **IMAGE PUBLISHING** 2002

Finnish Man's Biggest Fear Imagemag illustration

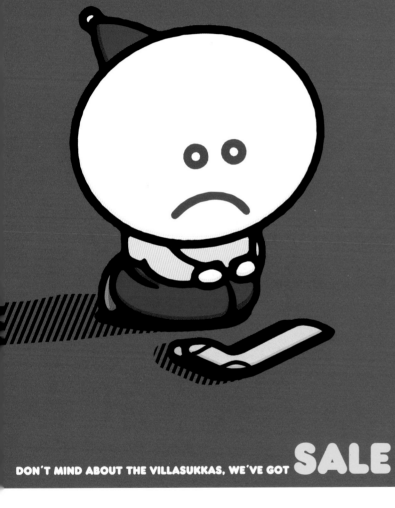

DON'T MIND ABOUT THE VILLASUKKAS, WE'VE GOT **SALE**

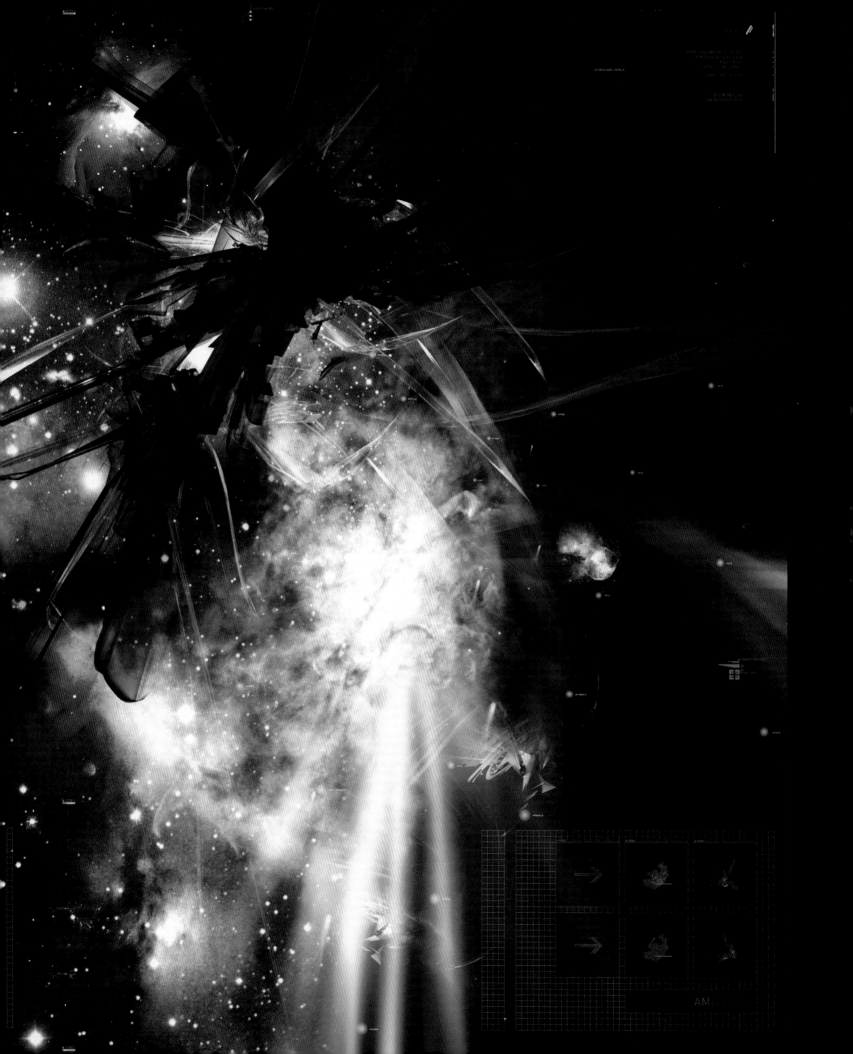

| ▬ | **Design** | Jens Karlsson | Ambience | Design for Digital Vision's Infinity series |

CONTRADICTIVE OMISSION OF THE FINAL DESTINATION ZX03 ST 443

ECHTHLIPSIS

VÄXJÖ NORRKÖPIN

MELOD

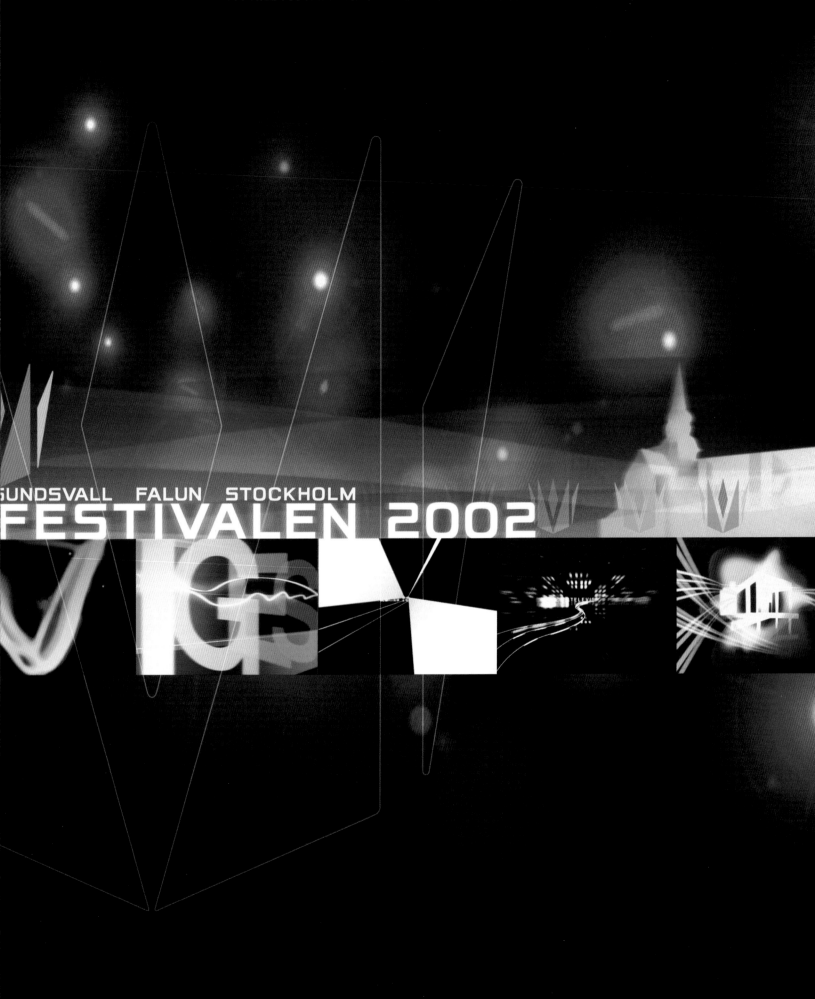

IDIOCASE **DIGITAL VISION** SWEDEN 2001

Design James Widegren **LP.** Transcendence Designs for Digital Vision's Infinity series

RP. Myriad Dysprosium

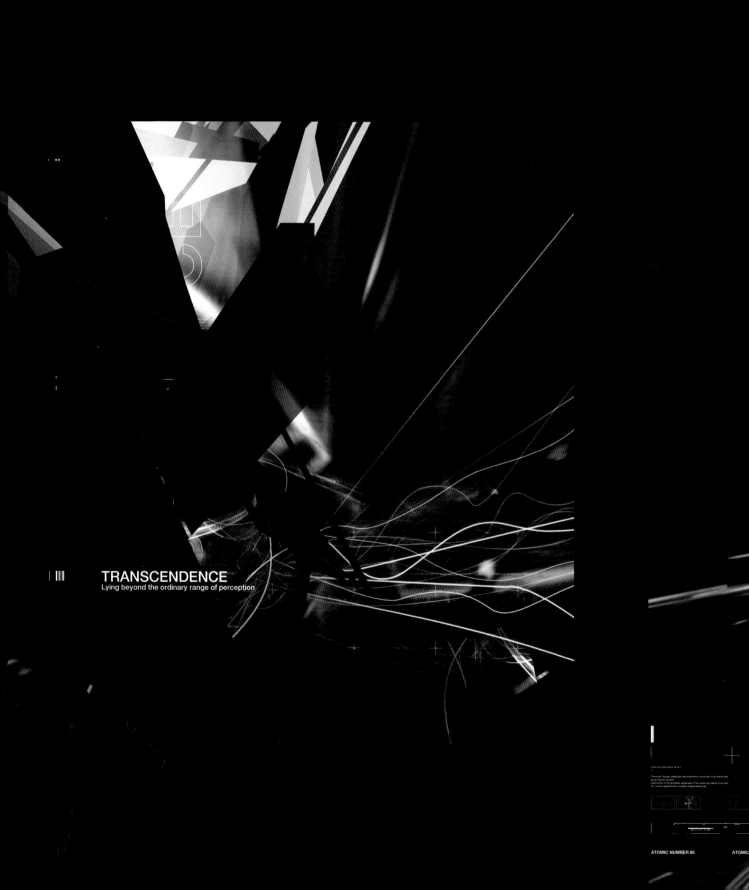

| |||

TRANSCENDENCE
Lying beyond the ordinary range of perception

ATOMIC NUMBER 66 ATOMIC WEIGHT 162.50

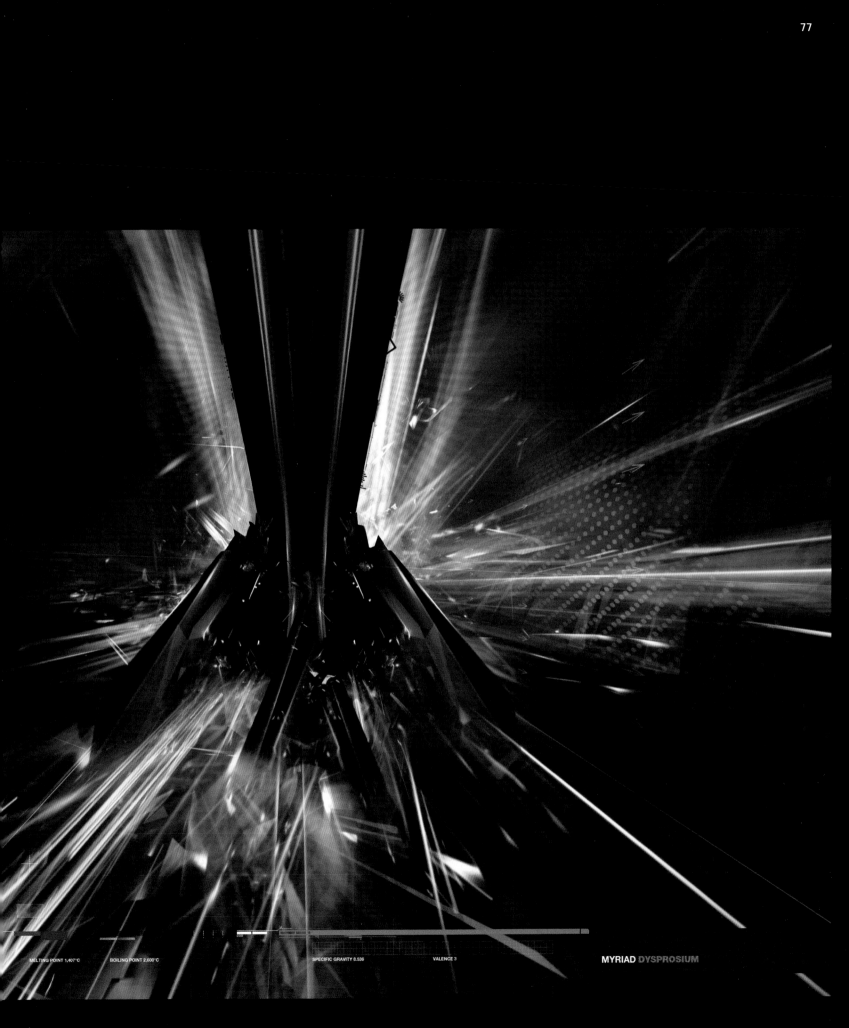

MELTING POINT 1,407°C BOILING POINT 2,600°C SPECIFIC GRAVITY 8.536 VALENCE 3

MYRIAD DYSPROSIUM

Design James Widegren GM eCruze Short promotional videos displayed at the Tokyo Motor Show
 Jens Karlsson

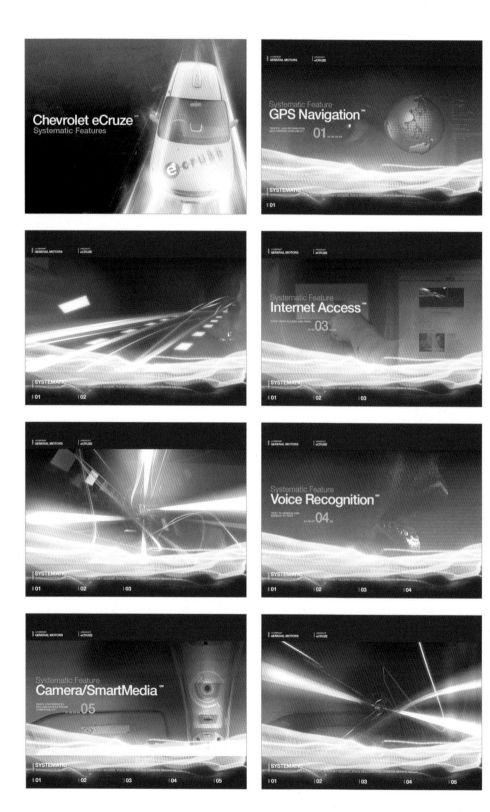

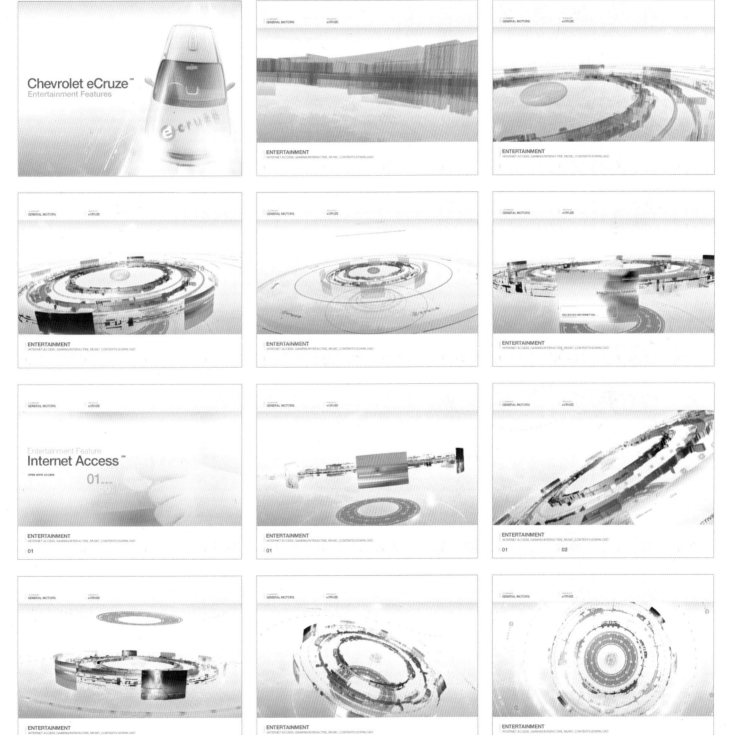

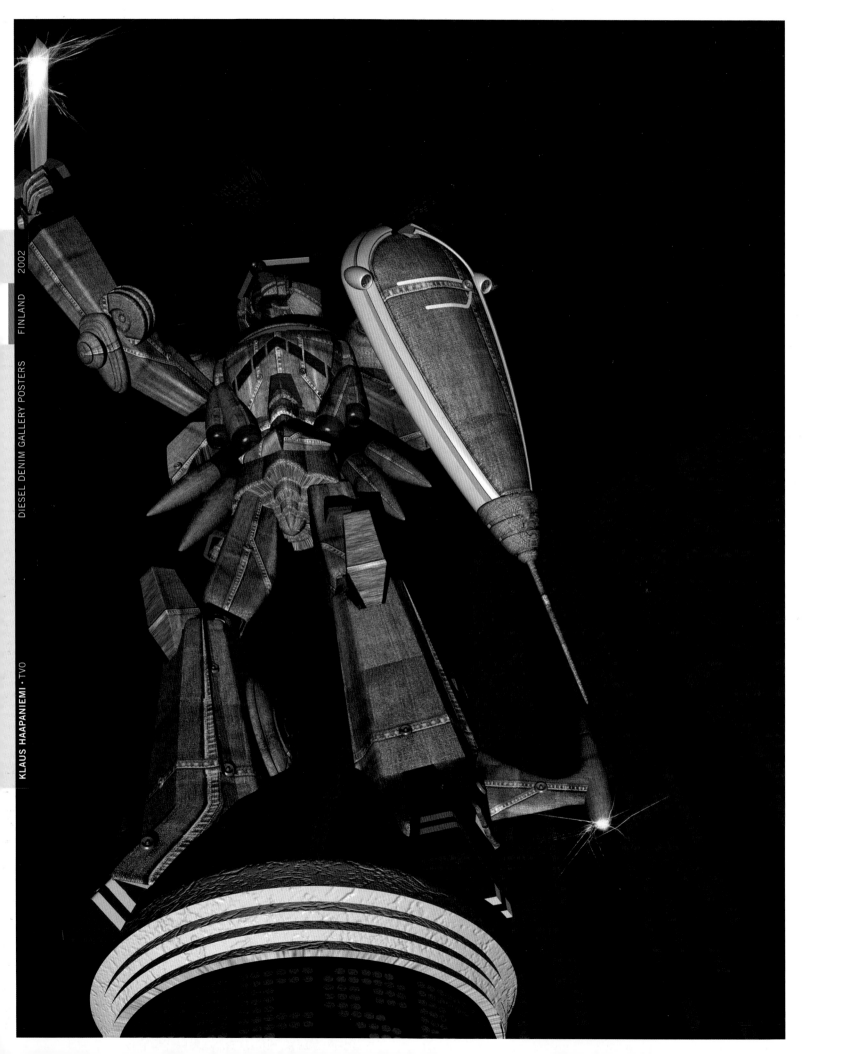

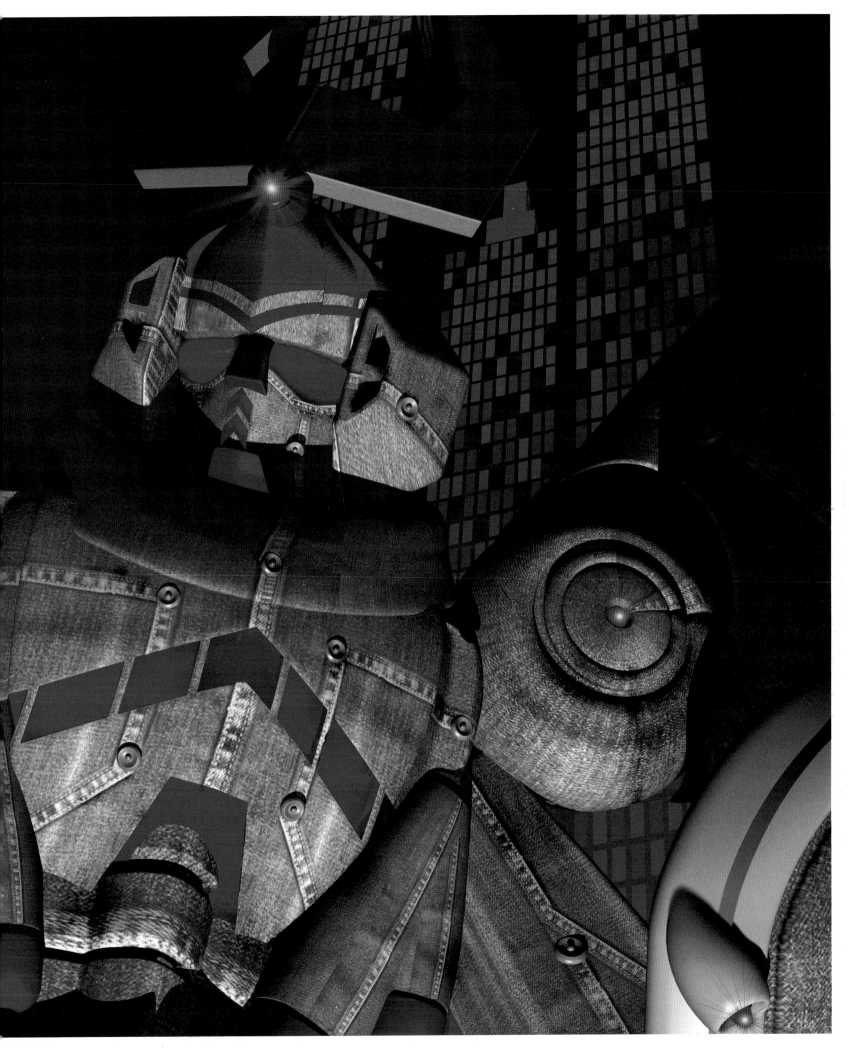

DFORM1 PERSONAL PROJECT DENMARK 2001

Design Anders Schroeder Dform1. Robo Made for personal use on website and for video pieces

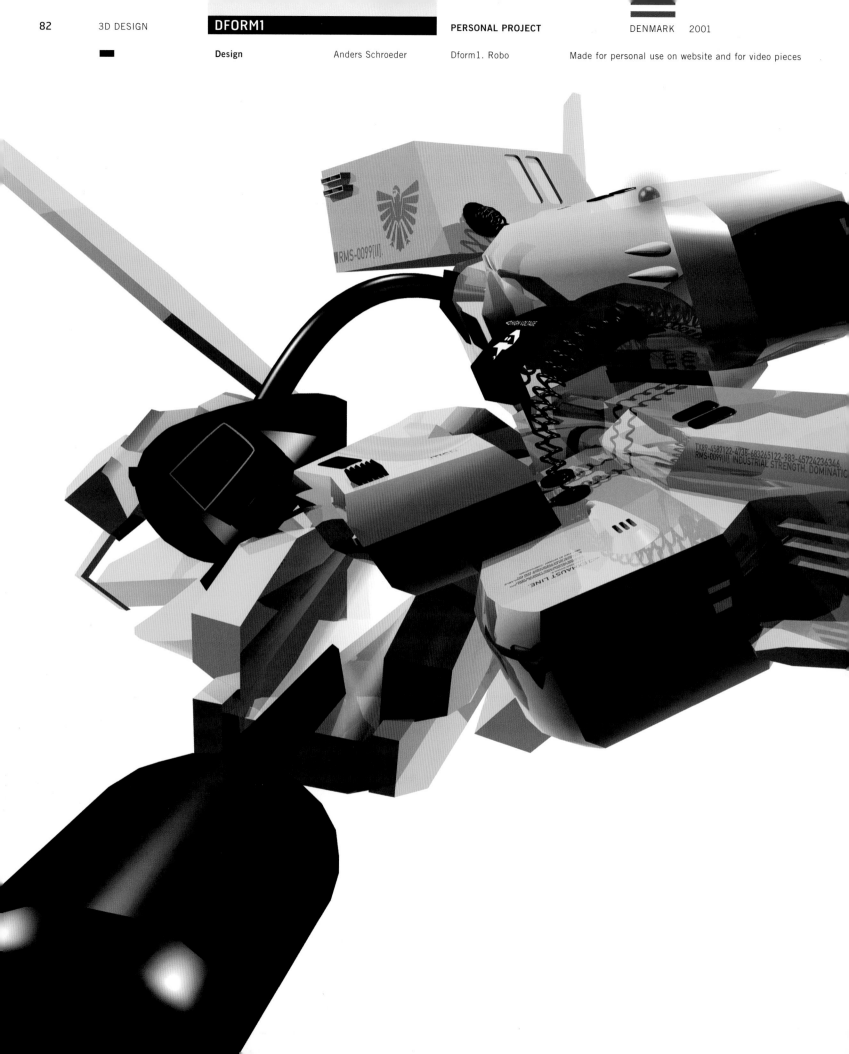

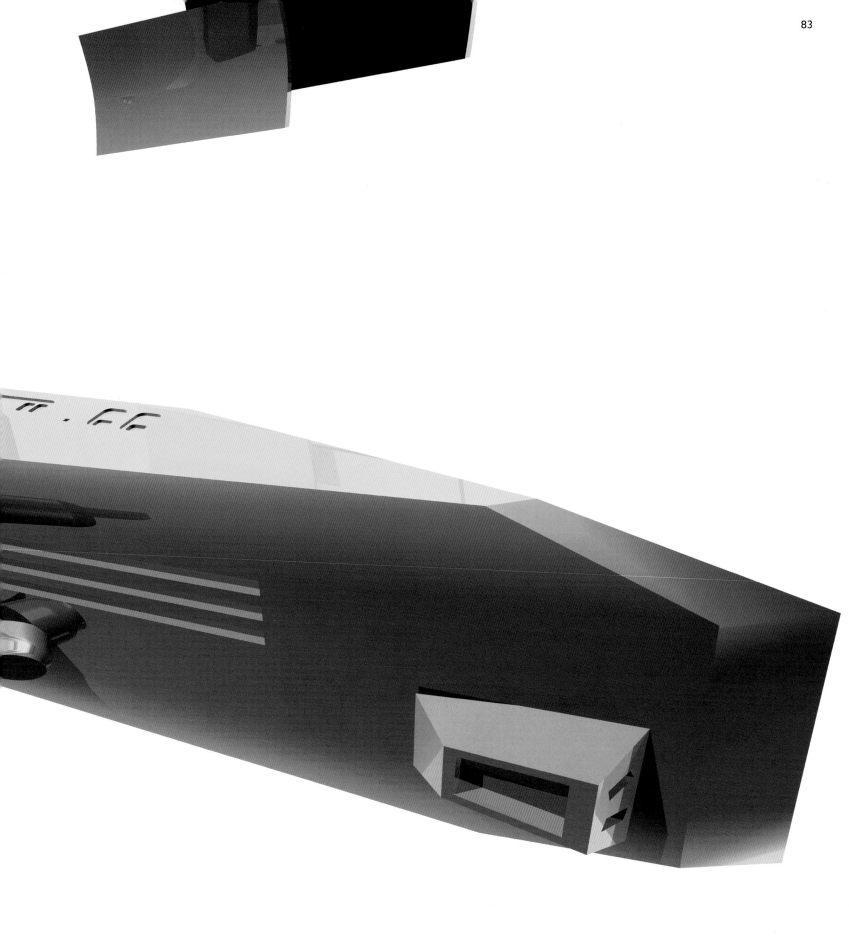

Design Anders Schroeder dform(one).shiftfunc Self-promotional portfolio site

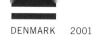

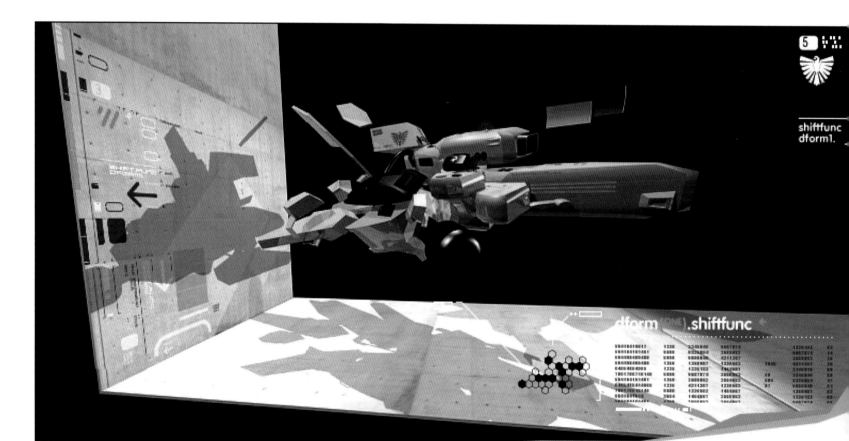

dform(one).shiftfunc. reunited.

After 5 years shiftfunc and dform(one) finally
managed to get their machines rolling again
and their minds synchronized. Honestly, they
forgot where they paused back in 95 but they
will continue from right here.

We're now open for freelance work, please
look through our portfolios:

➤ Goto dform(one) visual portfolio
➤ Goto dform(one) biography

➤ Goto shiftfunc audio portfolio

Just pet the robot and dig in...

dform(one) gotos:

go ahead >

shiftfunc gotos:

go ahead >

we love you:
mediatemple™ for supreme hosting
muce for the loading script

Tekstilkunst

Textile Art

Norske Tekstilkunstnere

Norwegian Textile Artists [NTK]

Norske Tekstilkunstnere Kirkegaten 1-3
N-0153 Oslo Norway
t [+47] 22 33 59 82
f [+47] 22 33 28 15
norsketekstilkunstnere.no
tekstilkunstnere.no

Art Direction　　　　Lars Steiner　　　　　　Dub Web　　　　　Images of the Dub website interface
Creative Direction　　Thomas Le Guellaff

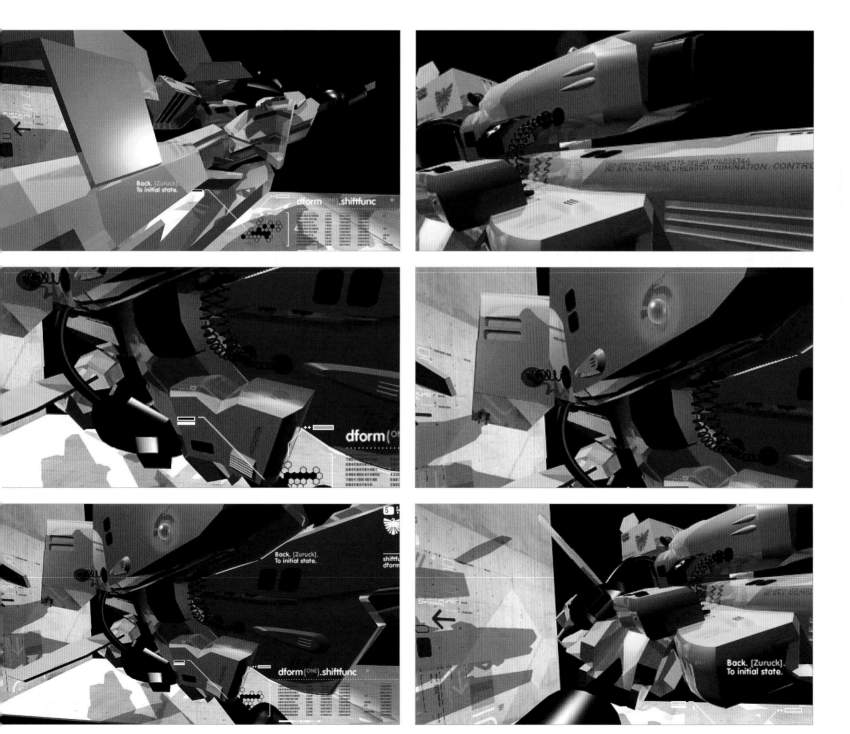

Design Erik Jarlsson **LP.** Metamorphic Studies 3D designs for personal website
RP. Metamorphic Studies Personal print work

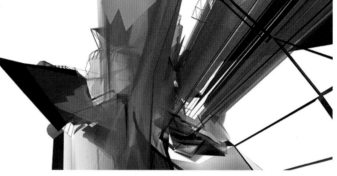

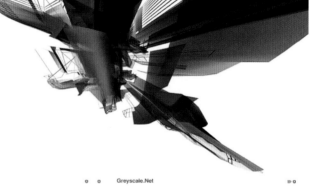

Greyscale.Net

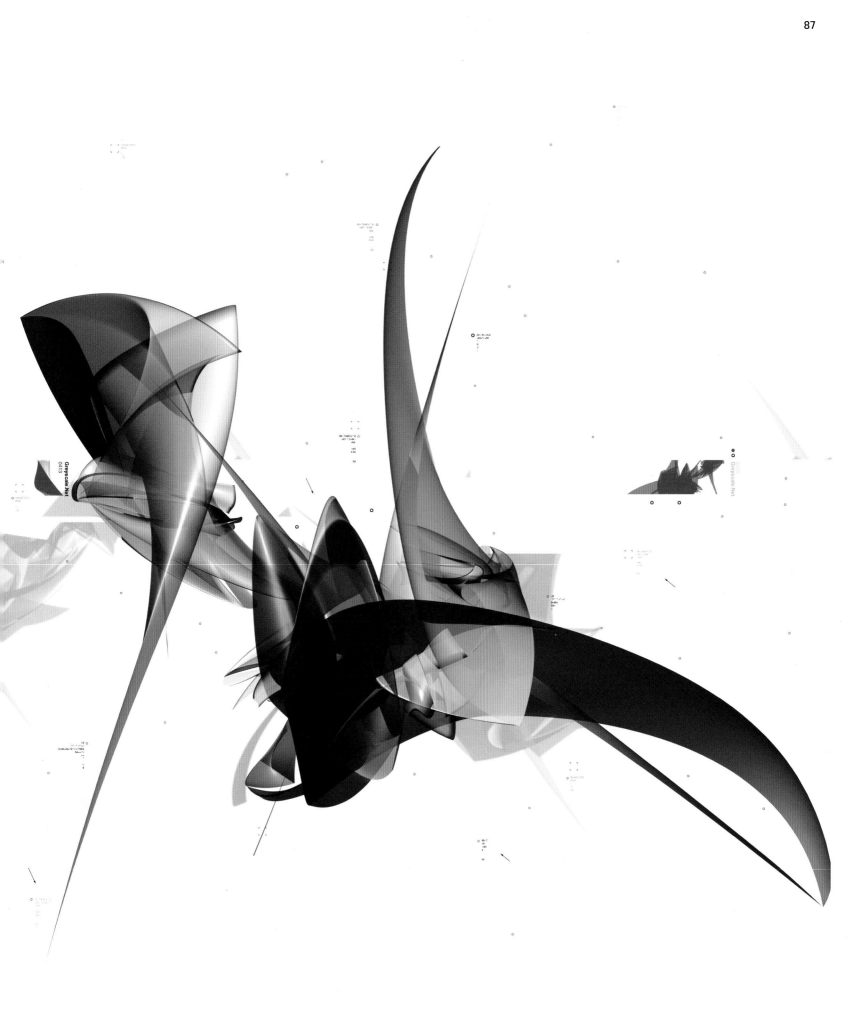

Greyscale Net
0413

Greyscale Net

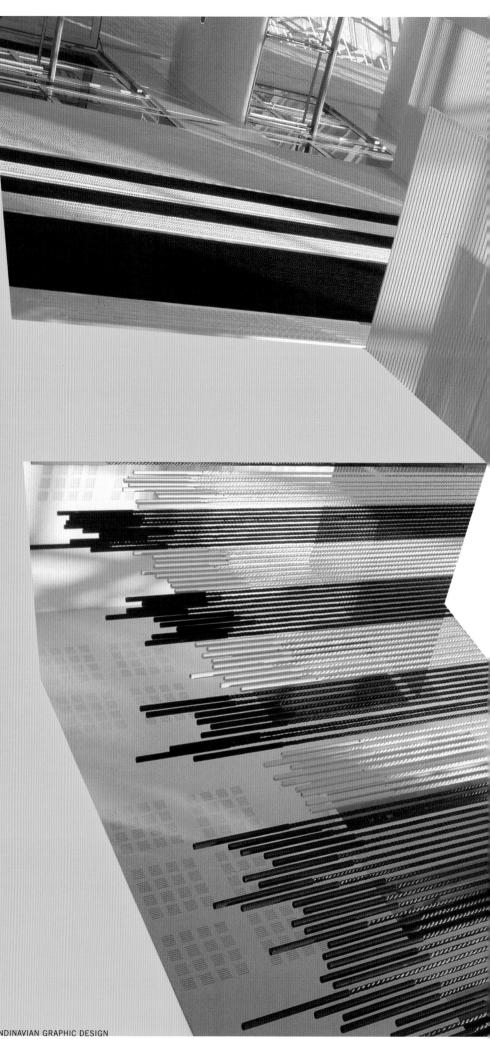

HALVOR BODIN · SUPERLOW

Design Jan Nilsson Screensaver From the Starsky website
Web Pages

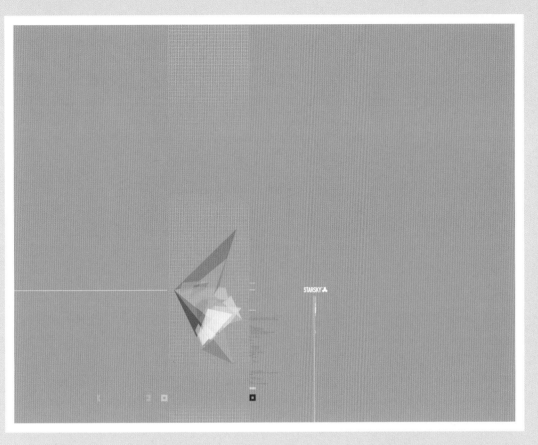

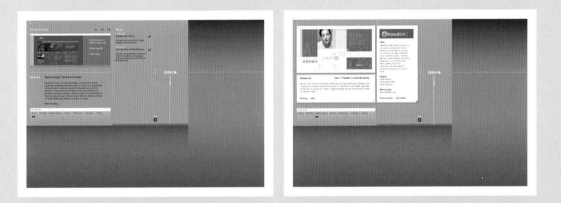

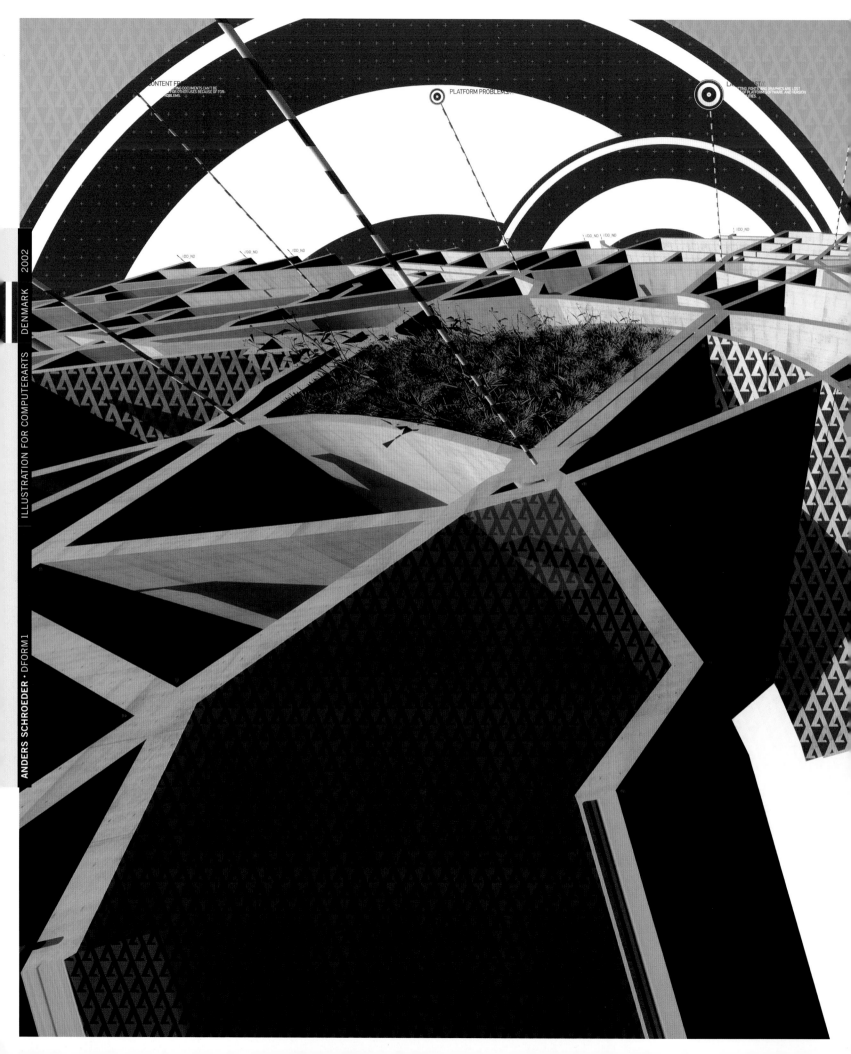

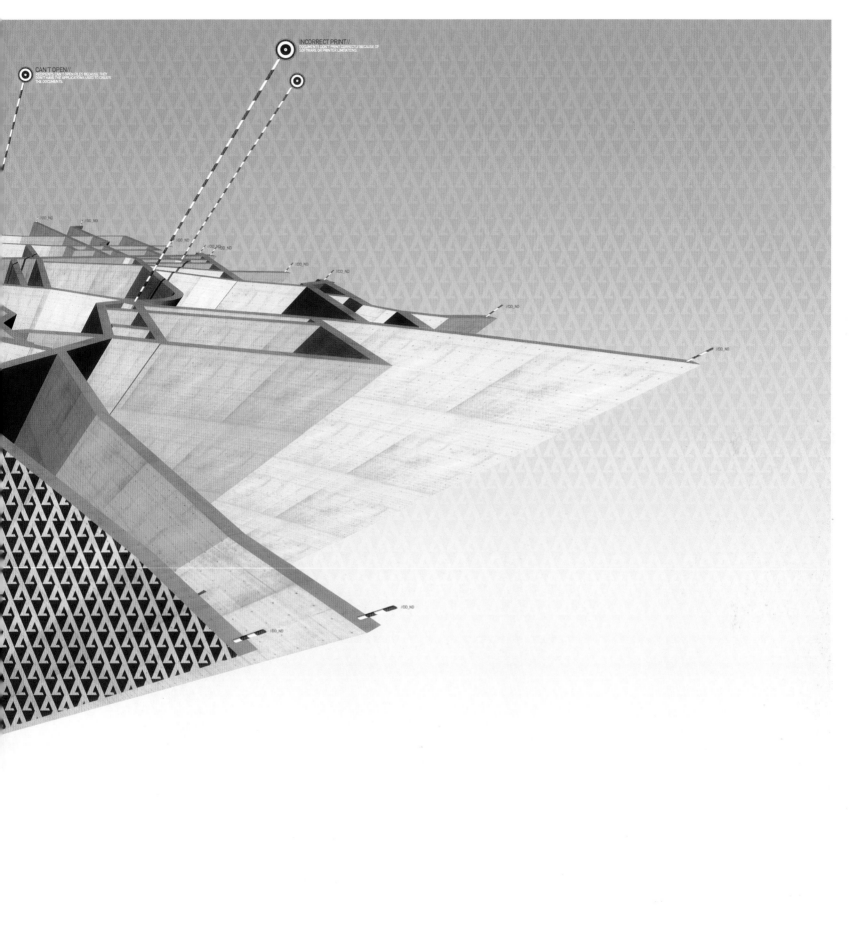

CAN'T OPEN//
RECIPIENTS CAN'T OPEN FILES BECAUSE THEY
DON'T HAVE THE APPLICATIONS USED TO CREATE
THE DOCUMENTS.

INCORRECT PRINT//
DOCUMENTS DON'T PRINT CORRECTLY BECAUSE OF
SOFTWARE OR PRINTER LIMITATIONS.

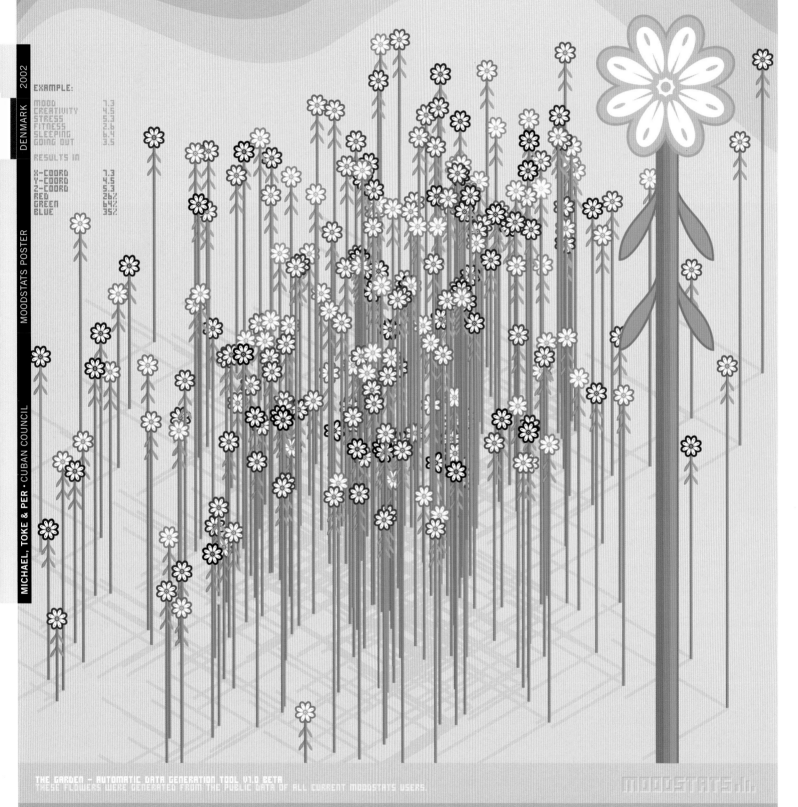

COME STROLL THROUGH THE LOVELY
MOODSTATS GARDEN

2002
DENMARK

MOODSTATS POSTER

MICHAEL, TOKE & PER · CUBAN COUNCIL

EXAMPLE:

MOOD	7.3
CREATIVITY	4.5
STRESS	5.3
FITNESS	2.6
SLEEPING	6.4
GOING OUT	3.5

RESULTS IN

X-COORD	7.3
Y-COORD	4.5
Z-COORD	5.3
RED	26%
GREEN	64%
BLUE	35%

THE GARDEN – AUTOMATIC DATA GENERATION TOOL V1.0 BETA
THESE FLOWERS WERE GENERATED FROM THE PUBLIC DATA OF ALL CURRENT MOODSTATS USERS

MOODSTATS.Ii

NUMBER OF USERS WITH THREE PUBLIC CATEGORIES: 466

WORLD TODAY MOOD RATING: 5.83
WORLD TODAY CREATIVITY RATING: 4.74
WORLD TODAY STRESS RATING: 4.18

WORLD AVERAGE MOOD RATING: 5.95
WORLD AVERAGE CREATIVITY RATING: 4.54
WORLD AVERAGE STRESS RATING: 4.35

ALLTIME HIGH MOOD RATING: 7.6 ON 2001.04.07
ALLTIME HIGH CREATIVITY RATING: 6.33 ON 2007.04.18
ALLTIME HIGH STRESS RATING: 6.92 ON 2001.09.11

MORE INFO AT WWW.MOODSTATS.COM

Design / Programming Toke Nygaard Moodstats Screens Diary application, monitoring both personal and global moods
 Michael Schmidt
 Per Jørgen Jørgensen

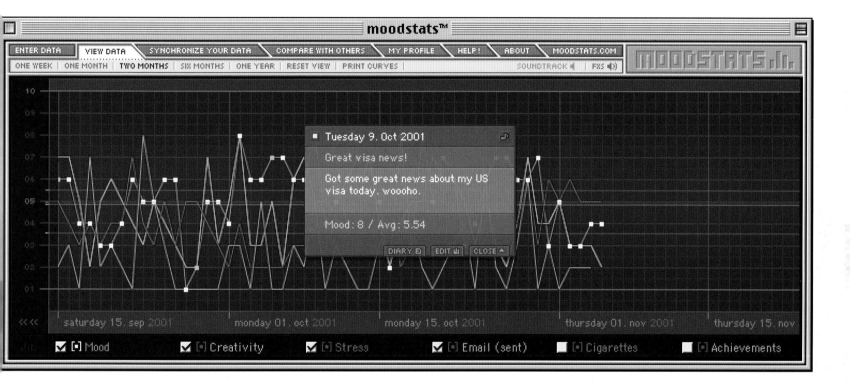

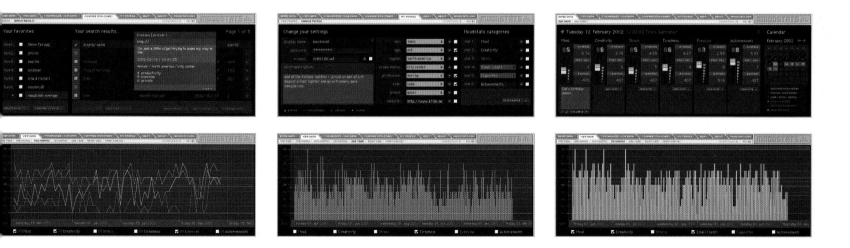

SEBASTIAN CAMPION ATONOMOUS

Design	Sebastian Campion	FluidText

Illustrating metatext and abstract communication spaces in our supermodern cities

Based on "The City, A Text", essays edited by Max Bruinsma

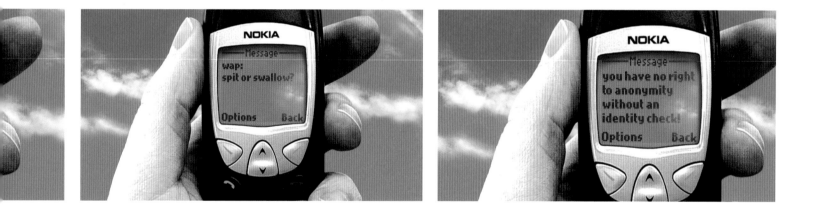

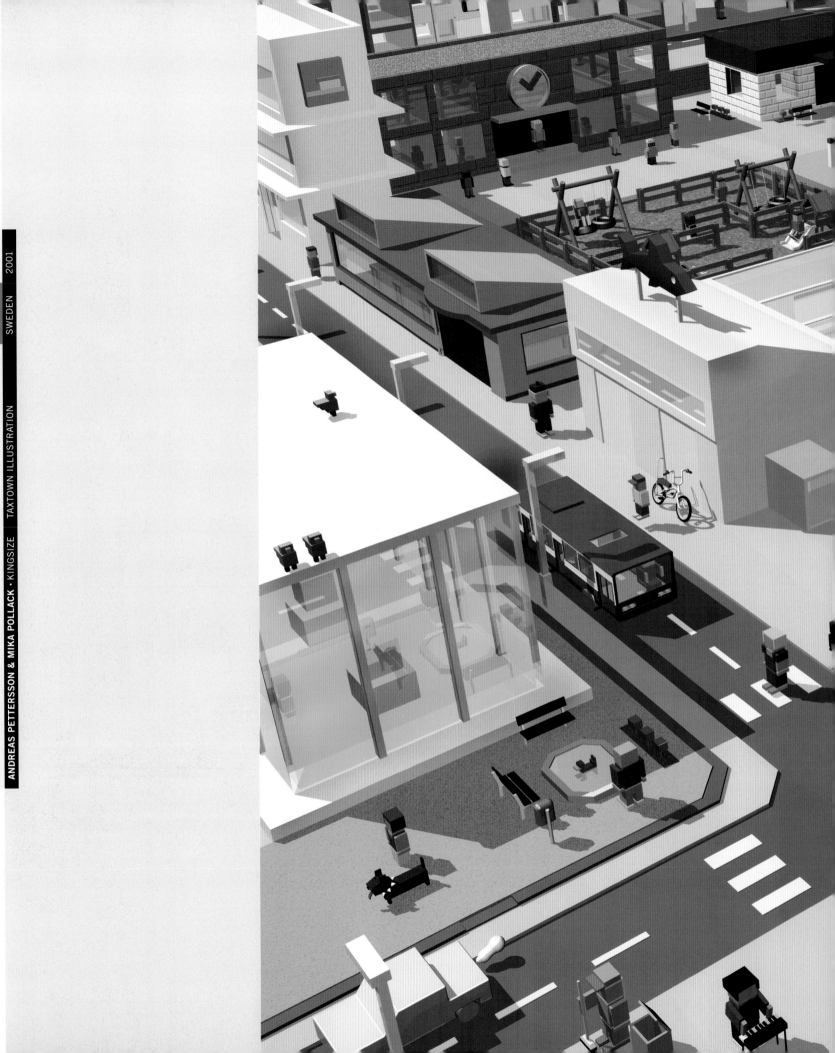

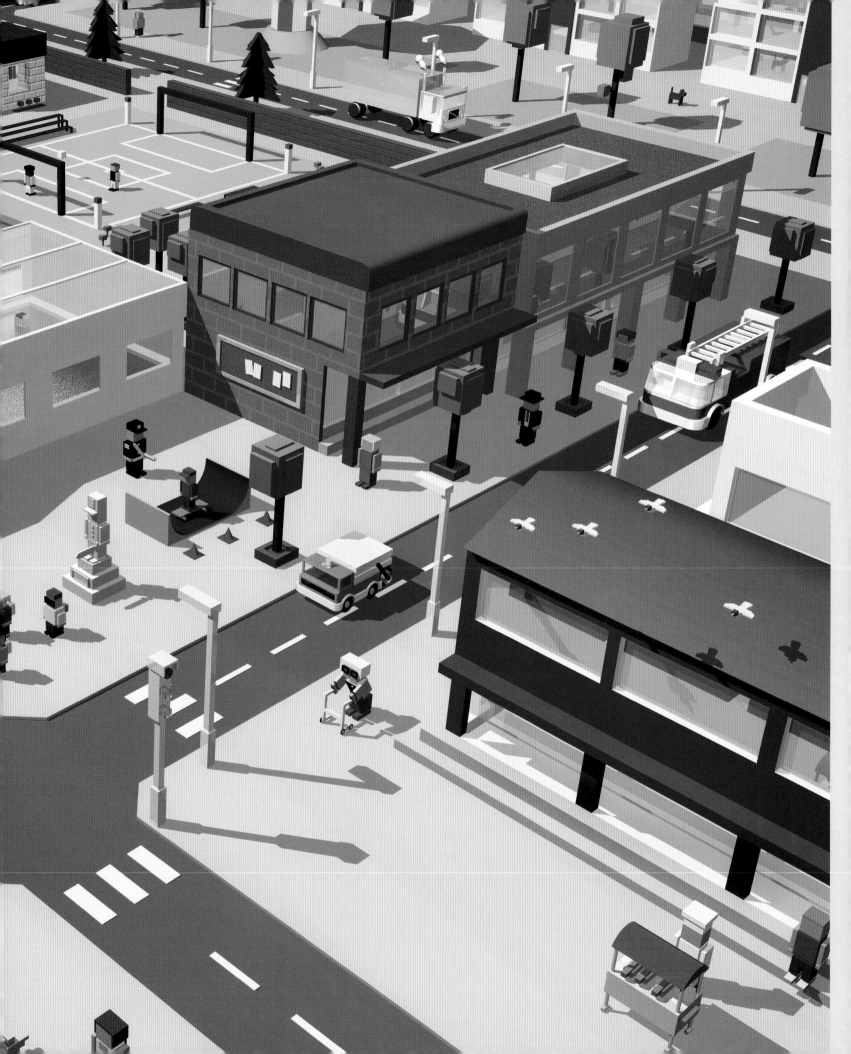

Design ACNE

LP. Digger & Slacker Two of the main characters in Netbabyworld
RP. Netbaby Characters Selected characters and merchandise from Netbabyworld
RP. Web Pages From Netbabyworld

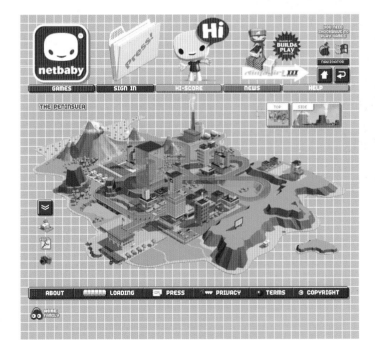

Design ACNE

LP. Machinedrum Actual machine and some of its identity design
RP. Machinedrum Display icon systems designs

THIS PIECE OF
MACHINE IS O.K.
Elvis

ARTWORK BY
Ziggy.

Design Andreas Pettersson Teddybears STHLM Characters and environment for music video and printed materials
 Mika Pollack

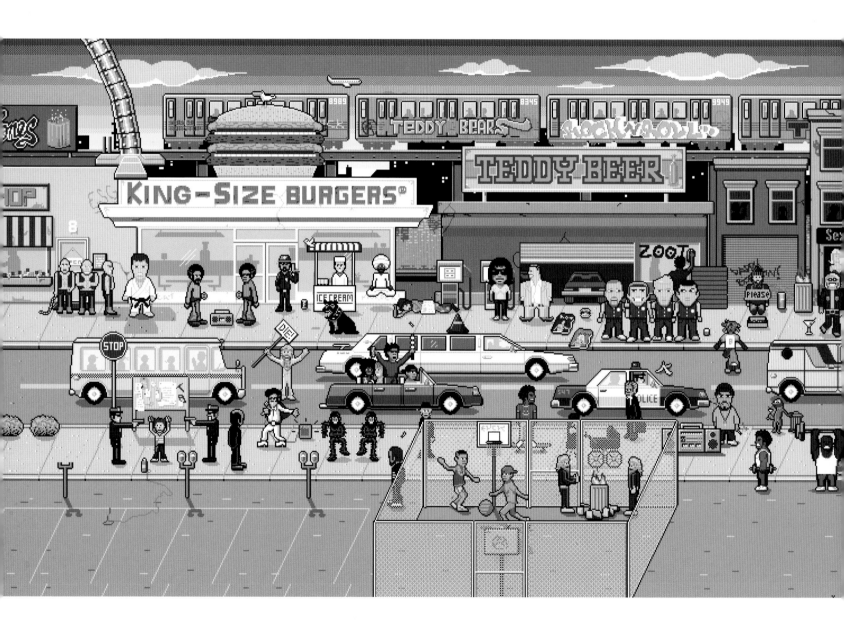

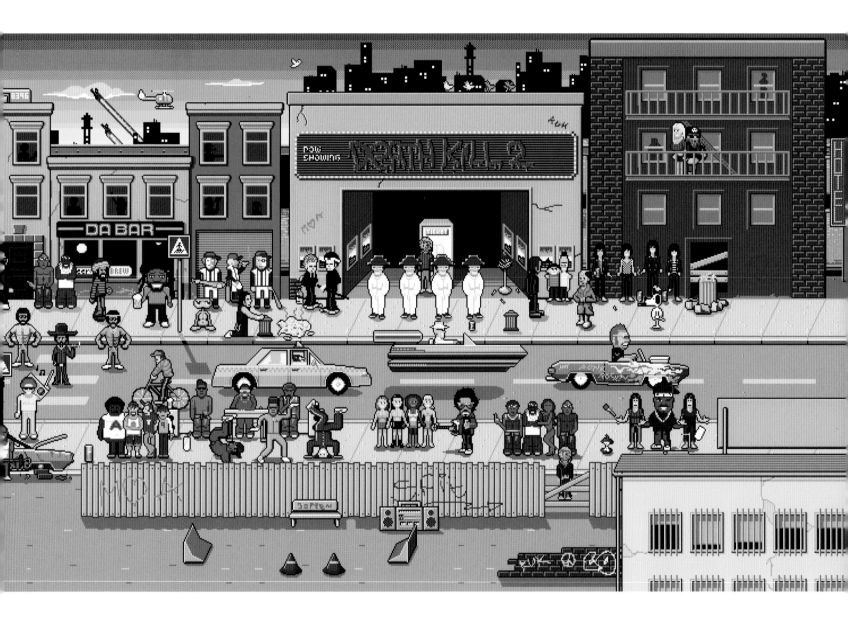

CUBAN COUNCIL **KALIBER 10 000** DENMARK 2002

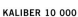
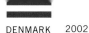

Design / Programming Toke Nygaard **LP.** K10k Front Page Appearance on April 2002 launch

Michael Schmidt **RP.** K10k Web Pages Selected details from within the K10k website

Per Jørgen Jørgensen

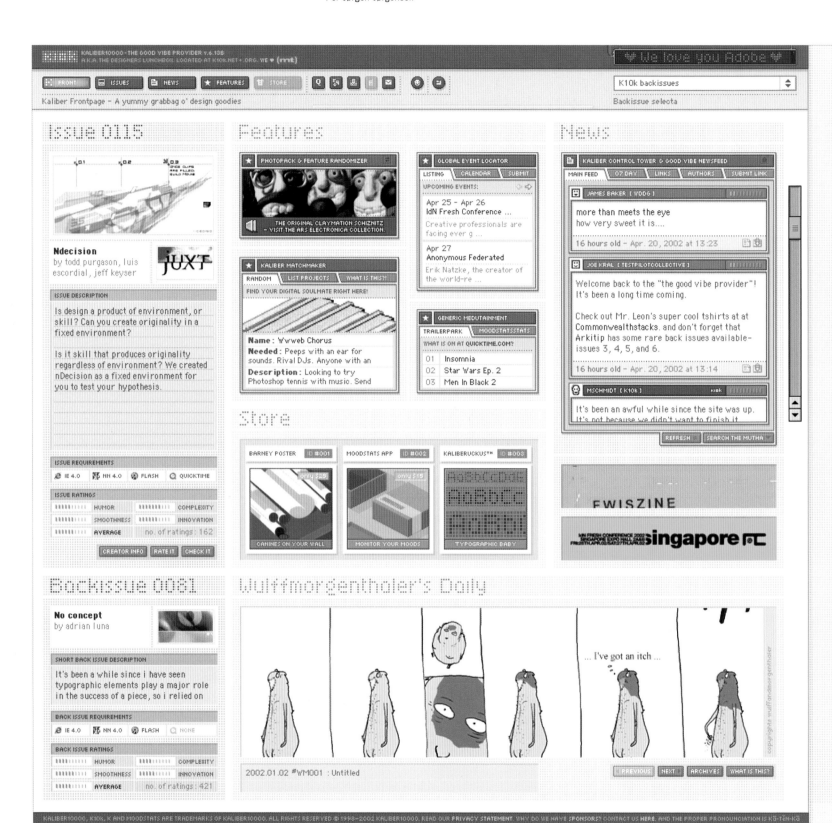

Design Toke Nygaard Pandæmonium Piece Projection installation piece for the Pandæmonium,
 Michael Schmidt Biennal of The Moving Image, London, UK
 Patrick Sundqvist

Smaller complete view, as well as separated larger version

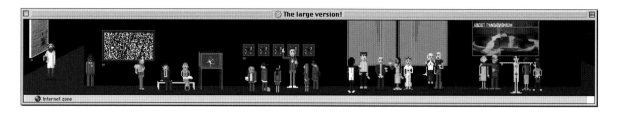

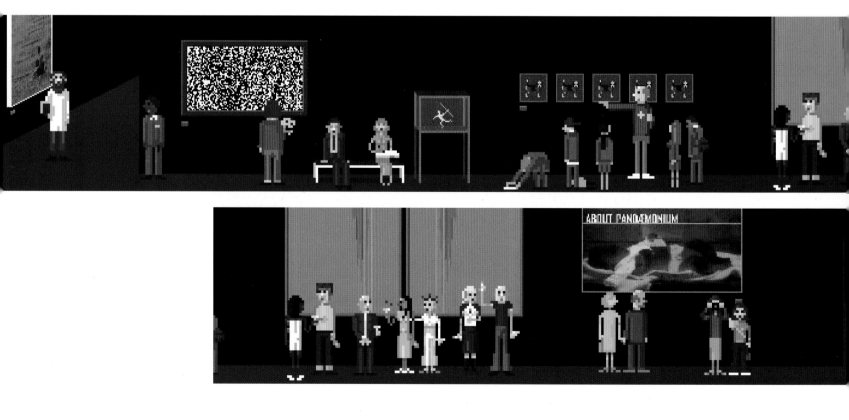

Design Toke Nygaard Project Save the LPC Poster commissioned by Threadless.com
Michael Schmidt

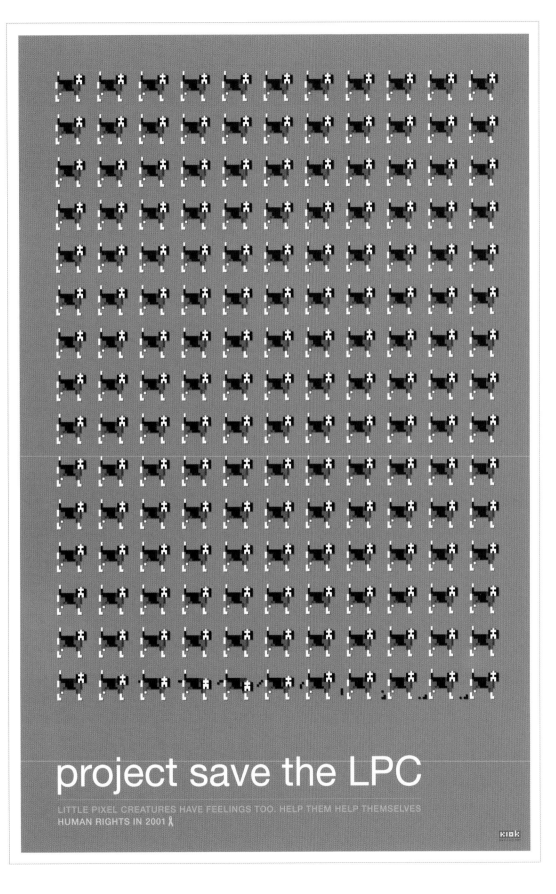

Design Toke Nygaard Project Save the LPC Poster commissioned by Threadless.com

Design Jonas Löfgren

Sleepy Jane
Dedicated Follower of Fashion

Characters for personal site, Little Eskimo

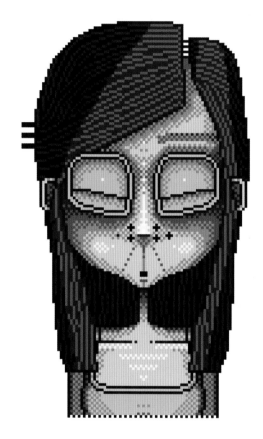

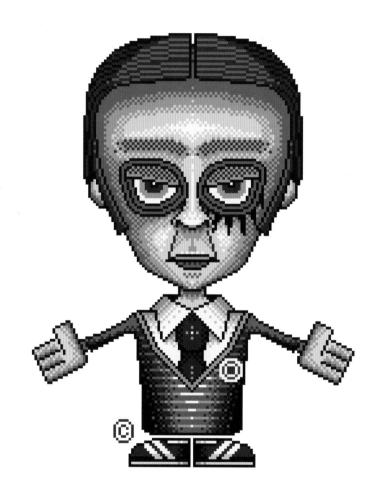

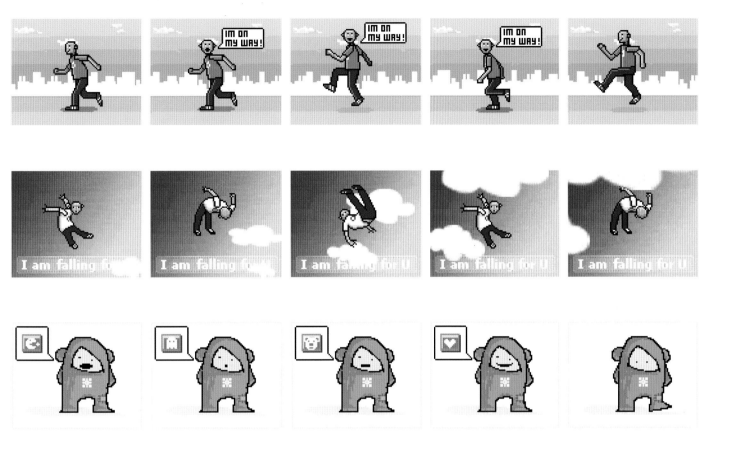

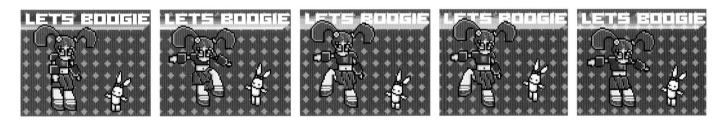

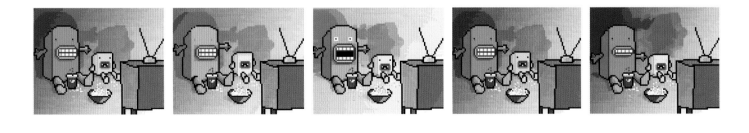

Design Martin Ström Harald Web Personal website Harald.net
 Peter Ström

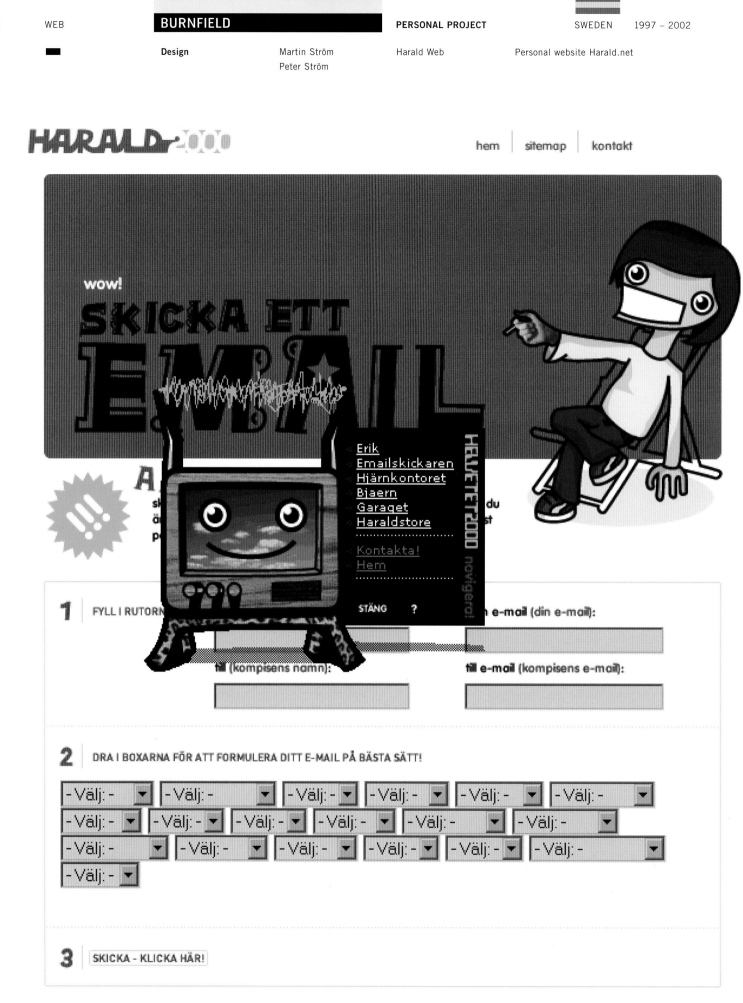

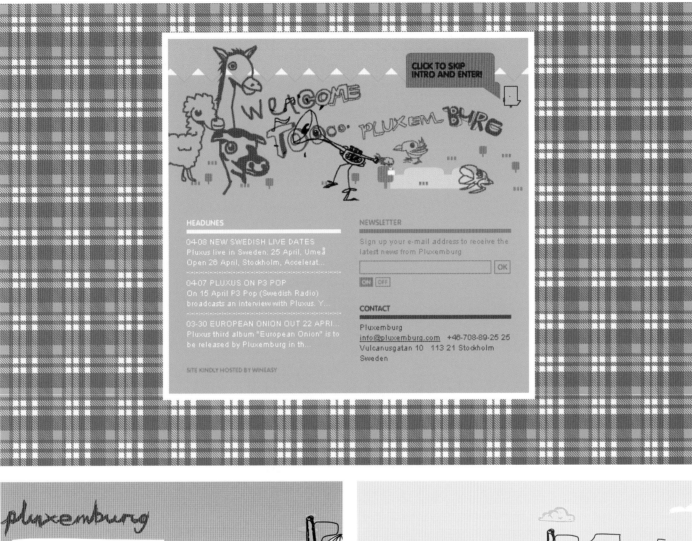

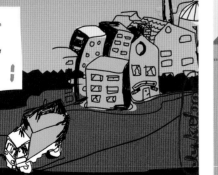

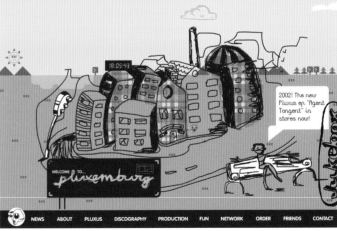

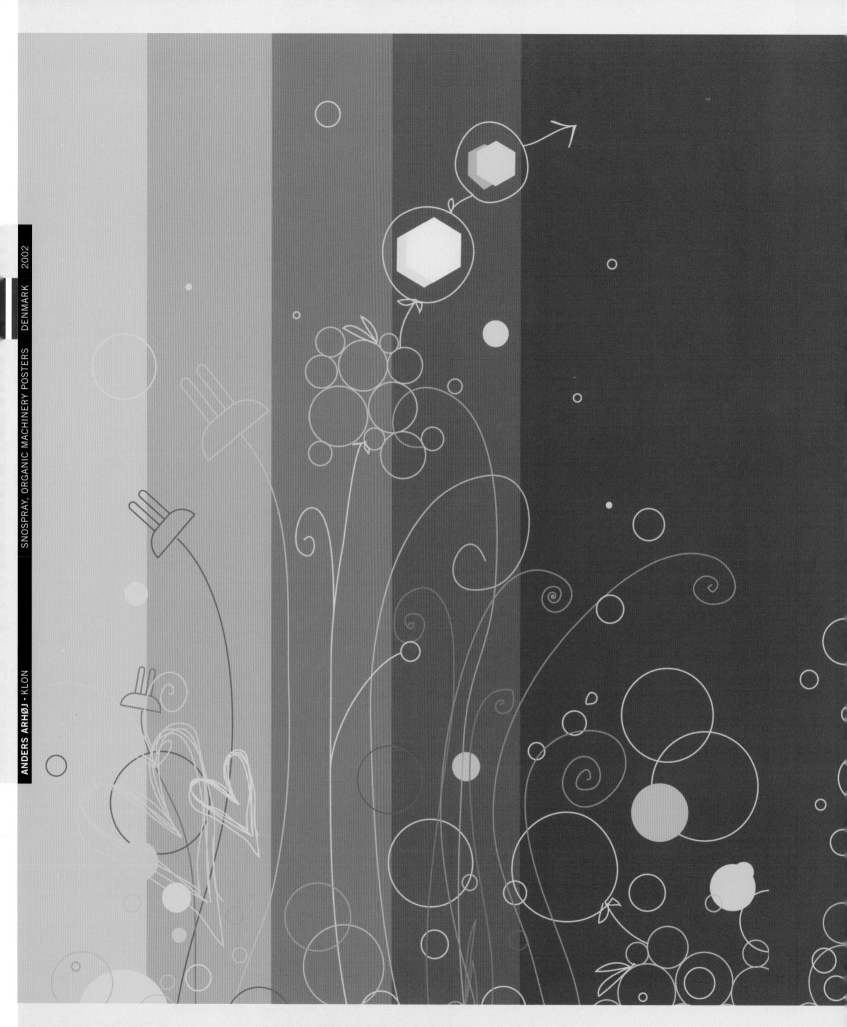

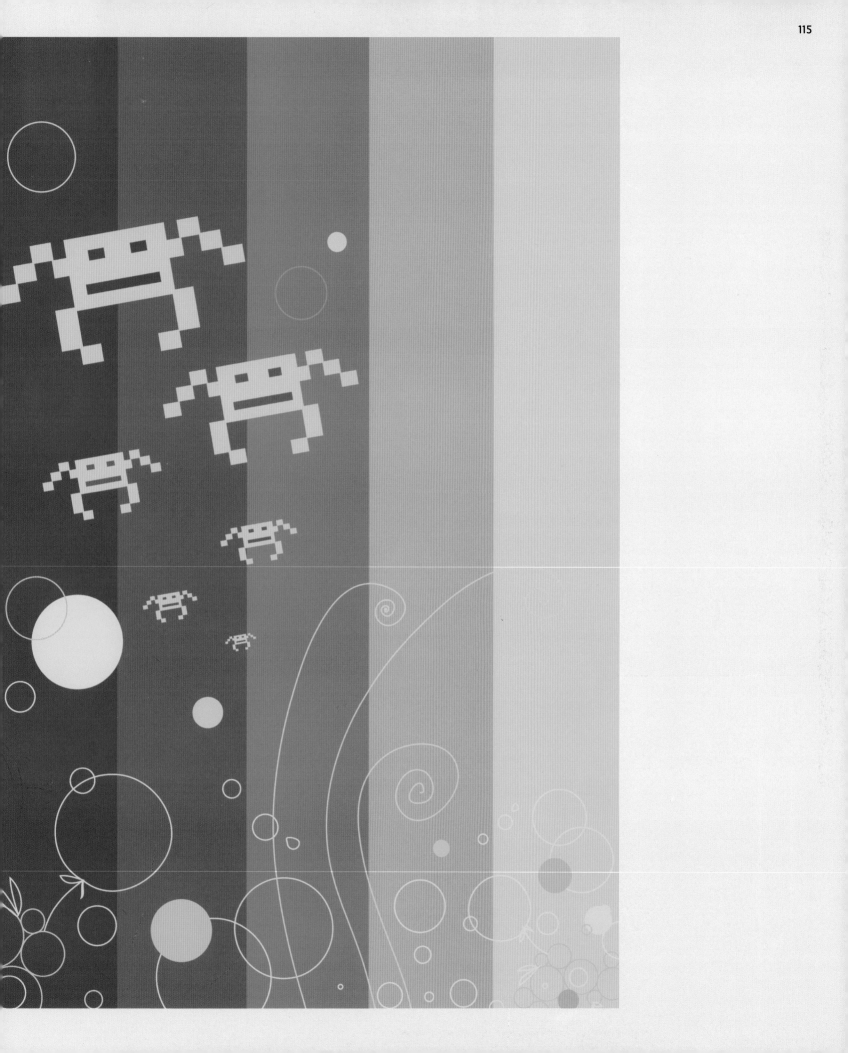

MONGREL ASSOCIATES ROGER FINLAND 2000

Design	Kustaa Saksi
Photography	Matti Pyykkö

LP. Roger CD Roger CD designs
RP. Roger Poster Roger promotional poster

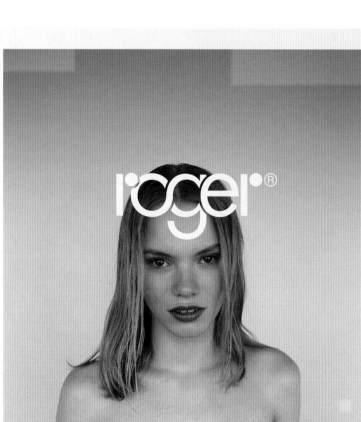

↖ PAGE02:"A GIRL POSING FOR CAMERA" ↖ NEVER BEEN JN A RIOT

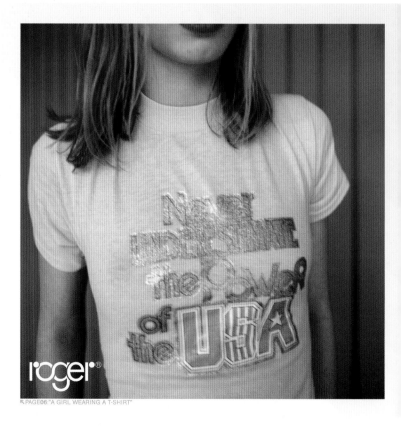

↖ PAGE06:"A GIRL WEARING A T-SHIRT"

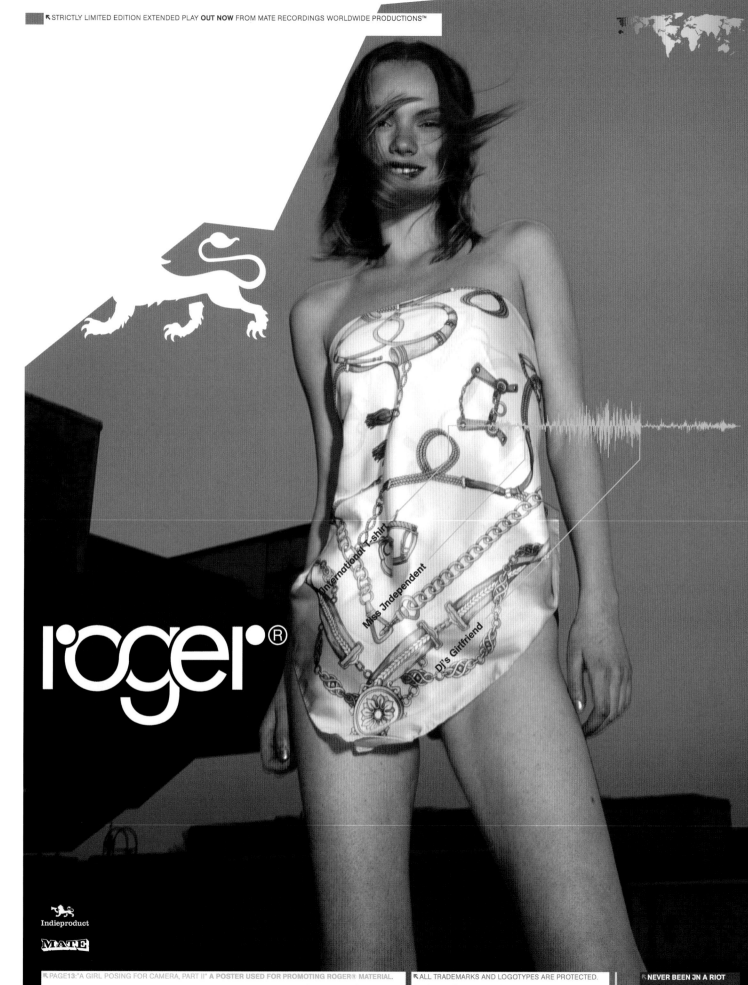

roger®

International T-shirt

Miss Jndependent

DJ's Girlfriend

Indieproduct

MATE

Design Bleed Bleed Posters Poster series promoting the fashion approved Bleed collection

FRED BØRRE LUNDBERG

DESIGN • SUPERLOW PHOTO • JOHAN WILDHAGEN INSIDE SPORT MAGAZINE SPREAD NORWAY 1998

et beskjedent

RÅSKINN

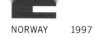

Design Subtopia Cybele Poster
Photography Per Heimly

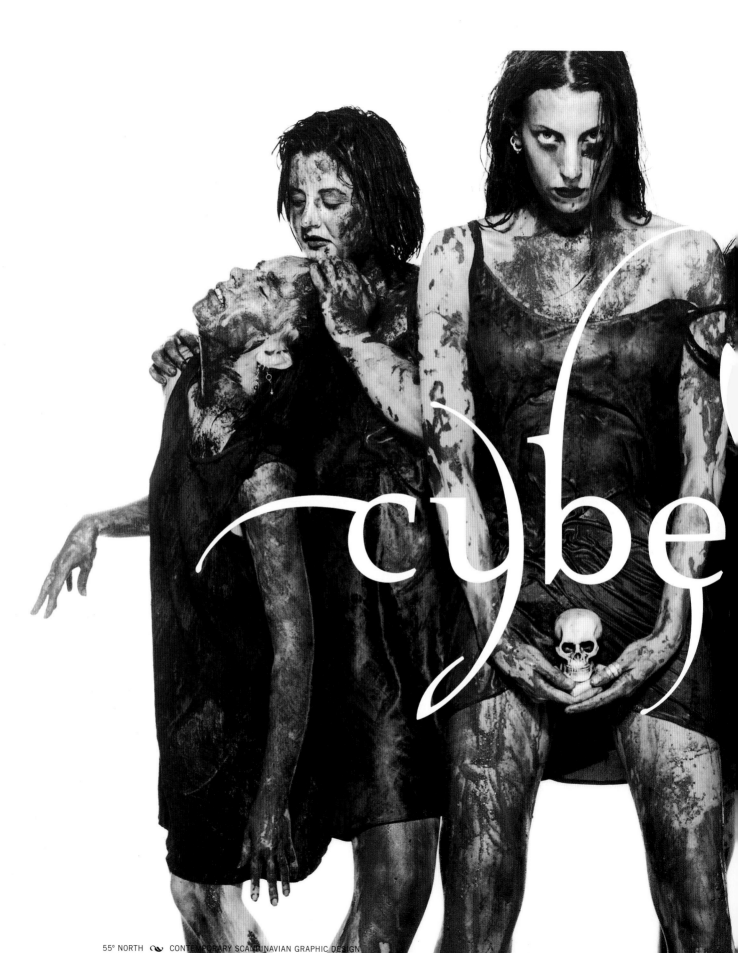

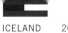

Design Gunnar Thor Vilhjalmsson **LP.** Minus Promotional poster
Photography Börkur Sigthorsson **RP.** Minus CD cover designs

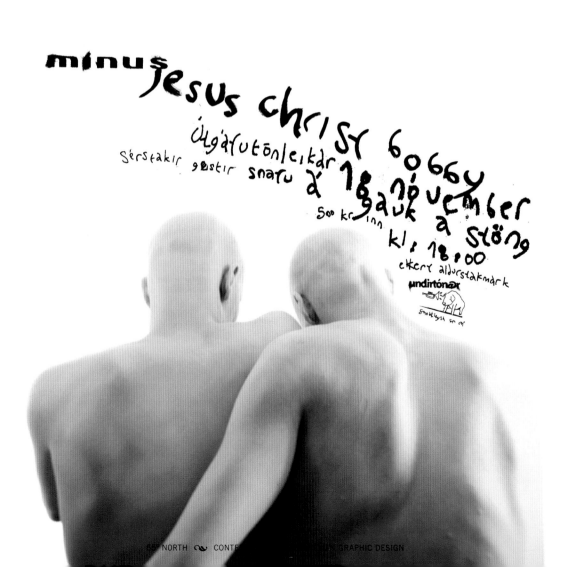

peccadillo

misdo

squeeze the Trigger

Placed the barrel under his chin and

Nobody must notice

Nobody must know

I'm perverted and the world
must not know)

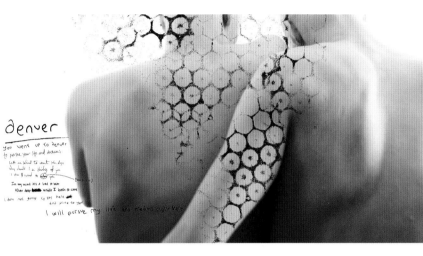

denver

I will pursue my life and dreams right here

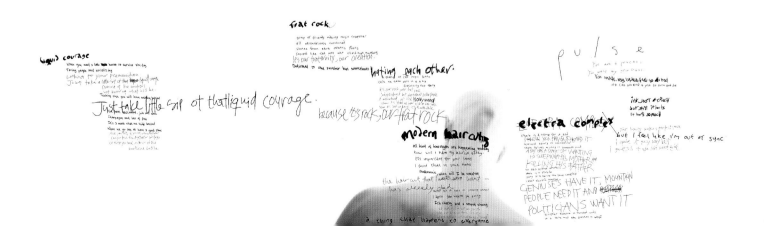

frat rock

liquid courage

Just take little sip of that liquid courage.

hating each other.

because its rock, our frat rock

modern haircuts

pulse

electra complex

GENIUSES HAVE IT, MOUNTAIN
PEOPLE NEED IT AND
POLITICIANS WANT IT

it's just a crush
but still it hurts
it hurts so much

but I feel like I'm out of sync

Design Halvor Bodin Buy Nothing Day Campaign poster series for the Buy Nothing Day 2001
Photography Marcel Lelienhof

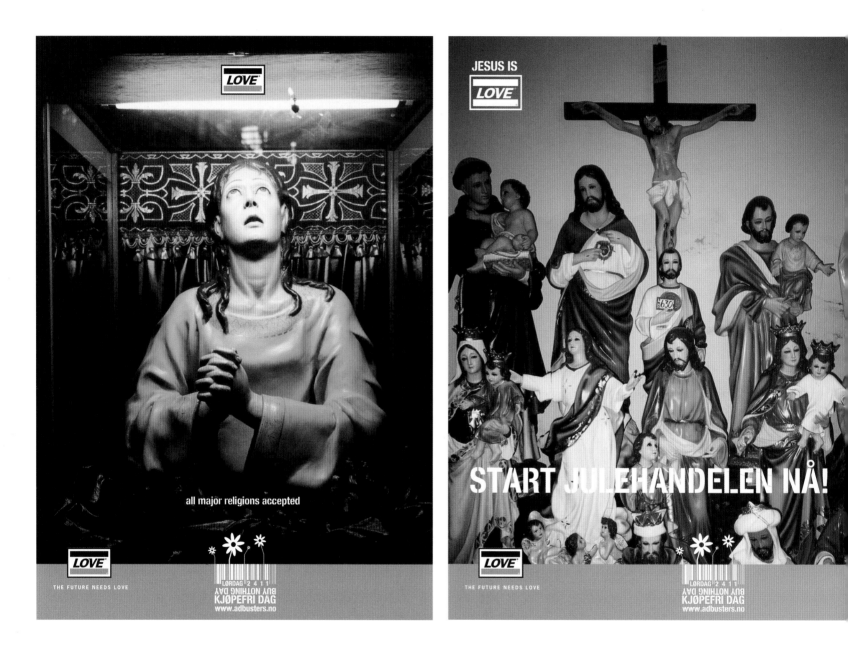

Design Subtopia Monuments Excerpt from Per Heimly's Monuments
Photography Per Heimly

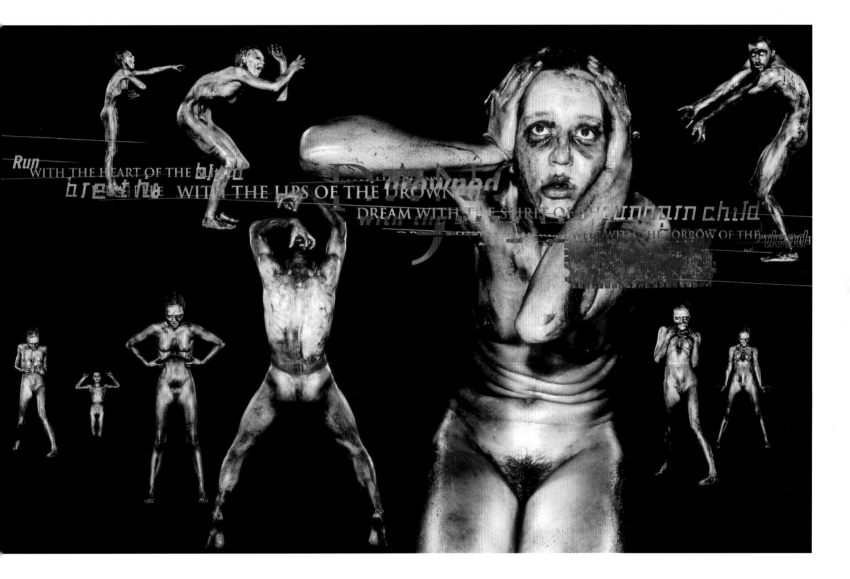

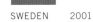
| Design | James Widegren | Popshop, Careless | CD single design |

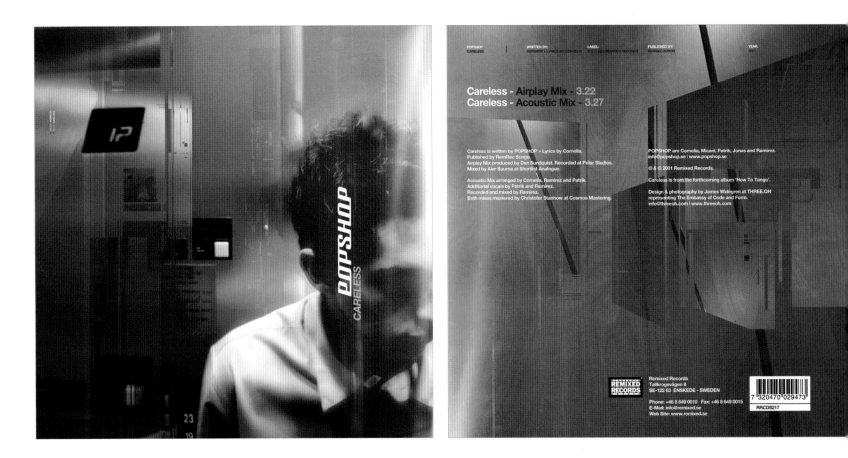

Design Ricky Tillblad Eclectic Bob CD front and back cover
Art Direction Ricky Tillblad

Design	Kim Granlund	Sam & Diane	Interactive fashion magazine story
Photography	Tammy Schoenfeld		
Stylist	Douglas Perrett		
Models	Sam, Diane Fleetwood		

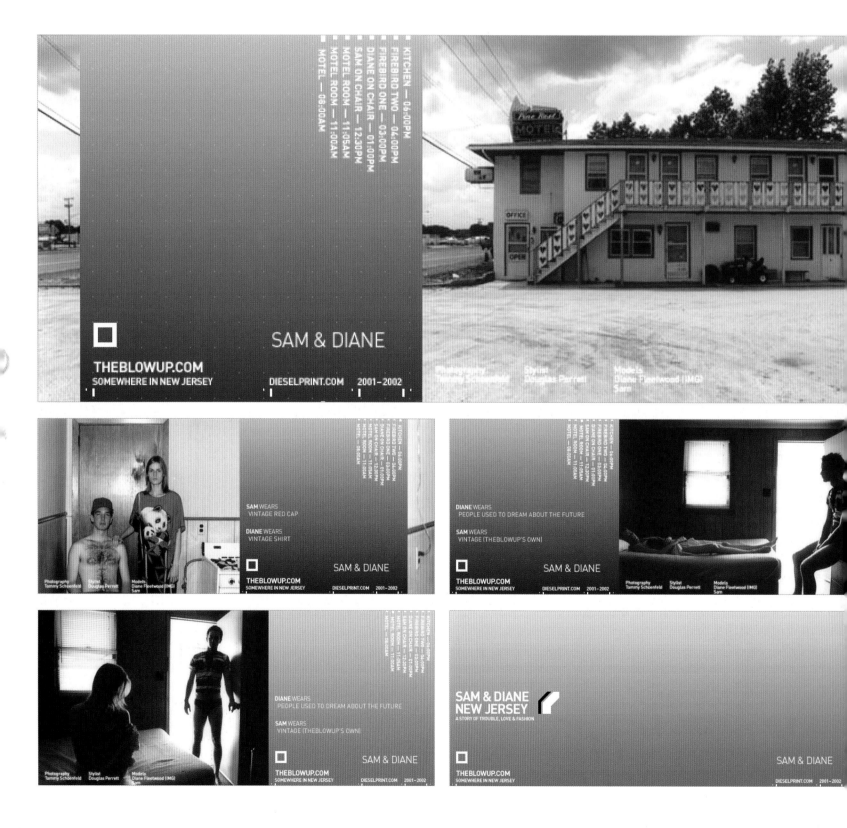

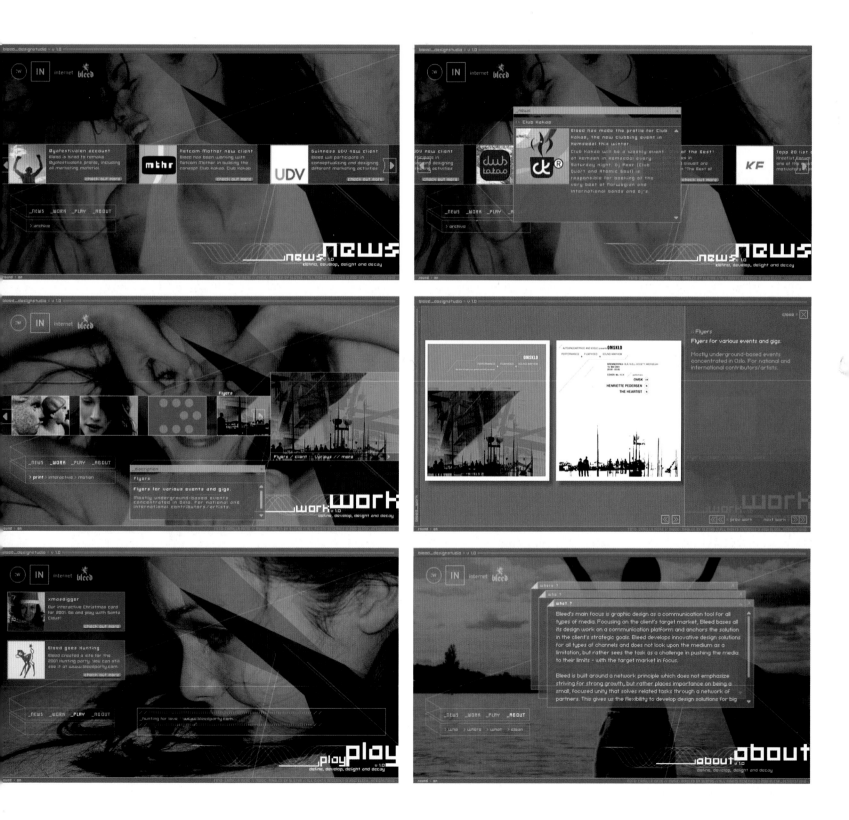

I HAVE NO MONEY, NO RESOURCES, NO HOPES. I AM THE HAPPIEST MAN ALIVE. A YEAR AGO, SIX MONTHS AGO, I THOUGHT THAT THEN? THIS IS NOT A BOOK. THIS IS LIBEL, SLANDER. DEFAMATION OF CHARACTER. THIS NOT A BOOK, IN THE ORDINARY SENSE.

ARTIST. I NO LONGER THINK ABOUT IT, I AM. EVERYTHING THAT WAS LITERATURE HAS FALLEN FROM ME. THERE ARE NO MORE BOOKS TO BE WRITTEN, THANK GOD. THIS
ORD. NO, THIS IS A PROLONGED INSULT, A GOB OF SPIT IN THE FACE OF ART, A KICK IN THE PANTS TO GOD, MAN, DESTINY, TIME, LOVE, BEAUTY...WHAT YOU WILL.
ARTIST. I NO LONGER THINK ABOUT IT, I AM. EVERYTHING THAT WAS LITERATURE HAS FALLEN FROM ME. THERE ARE NO MORE BOOKS TO BE WRITTEN, THANK GOD. THIS
ORD. NO, THIS IS A PROLONGED INSULT, A GOB OF SPIT IN THE FACE OF ART, A KICK IN THE PANTS TO GOD, MAN, DESTINY, TIME, LOVE, BEAUTY...WHAT YOU WILL.
ARTIST. I NO LONGER THINK ABOUT IT, I AM. EVERYTHING THAT WAS LITERATURE HAS FALLEN FROM ME. THERE ARE NO MORE BOOKS TO BE WRITTEN, THANK GOD. THIS
ORD. NO, THIS IS A PROLONGED INSULT, A GOB OF SPIT IN THE FACE OF ART, A KICK IN THE PANTS TO GOD, MAN, DESTINY, TIME, LOVE, BEAUTY...WHAT YOU WILL.
ARTIST. I NO LONGER THINK ABOUT IT, I AM. EVERYTHING THAT WAS LITERATURE HAS FALLEN FROM ME. THERE ARE NO MORE BOOKS TO BE WRITTEN, THANK GOD. THIS
ORD. NO, THIS IS A PROLONGED INSULT, A GOB OF SPIT IN THE FACE OF ART, A KICK IN THE PANTS TO GOD, MAN, DESTINY, TIME, LOVE, BEAUTY...WHAT YOU WILL.
ARTIST. I NO LONGER THINK ABOUT IT, I AM. EVERYTHING THAT WAS LITERATURE HAS FALLEN FROM ME. THERE ARE NO MORE BOOKS TO BE WRITTEN, THANK GOD. THIS
ORD. NO, THIS IS A PROLONGED INSULT, A GOB OF SPIT IN THE FACE OF ART, A KICK IN THE PANTS TO GOD, MAN, DESTINY, TIME, LOVE, BEAUTY...WHAT YOU WILL.
ARTIST. I NO LONGER THINK ABOUT IT, I AM. EVERYTHING THAT WAS LITERATURE HAS FALLEN FROM ME. THERE ARE NO MORE BOOKS TO BE WRITTEN, THANK GOD. THIS
ORD. NO, THIS IS A PROLONGED INSULT, A GOB OF SPIT IN THE FACE OF ART, A KICK IN THE PANTS TO GOD, MAN, DESTINY, TIME, LOVE, BEAUTY...WHAT YOU WILL.
ARTIST. I NO LONGER THINK ABOUT IT, I AM. EVERYTHING THAT WAS LITERATURE HAS FALLEN FROM ME. THERE ARE NO MORE BOOKS TO BE WRITTEN, THANK GOD. THIS
ORD. NO, THIS IS A PROLONGED INSULT, A GOB OF SPIT IN THE FACE OF ART, A KICK IN THE PANTS TO GOD, MAN, DESTINY, TIME, LOVE, BEAUTY...WHAT YOU WILL.
ARTIST. I NO LONGER THINK ABOUT IT, I AM. EVERYTHING THAT WAS LITERATURE HAS FALLEN FROM ME. THERE ARE NO MORE BOOKS TO BE WRITTEN, THANK GOD. THIS
ORD. NO, THIS IS A PROLONGED INSULT, A GOB OF SPIT IN THE FACE OF ART, A KICK IN THE PANTS TO GOD, MAN, DESTINY, TIME, LOVE, BEAUTY...WHAT YOU WILL.
ARTIST. I NO LONGER THINK ABOUT IT, I AM. EVERYTHING THAT WAS LITERATURE HAS FALLEN FROM ME. THERE ARE NO MORE BOOKS TO BE WRITTEN, THANK GOD. THIS
ORD. NO, THIS IS A PROLONGED INSULT, A GOB OF SPIT IN THE FACE OF ART, A KICK IN THE PANTS TO GOD, MAN, DESTINY, TIME, LOVE, BEAUTY...WHAT YOU WILL.
ARTIST. I NO LONGER THINK ABOUT IT, I AM. EVERYTHING THAT WAS LITERATURE HAS FALLEN FROM ME. THERE ARE NO MORE BOOKS TO BE WRITTEN, THANK GOD. THIS
ORD. NO, THIS IS A PROLONGED INSULT, A GOB OF SPIT IN THE FACE OF ART, A KICK IN THE PANTS TO GOD, MAN, DESTINY, TIME, LOVE, BEAUTY...WHAT YOU WILL.
ARTIST. I NO LONGER THINK ABOUT IT, I AM. EVERYTHING THAT WAS LITERATURE HAS FALLEN FROM ME. THERE ARE NO MORE BOOKS TO BE WRITTEN, THANK GOD. THIS
ORD. NO, THIS IS A PROLONGED INSULT, A GOB OF SPIT IN THE FACE OF ART, A KICK IN THE PANTS TO GOD, MAN, DESTINY, TIME, LOVE, BEAUTY...WHAT YOU WILL.
ARTIST. I NO LONGER THINK ABOUT IT, I AM. EVERYTHING THAT WAS LITERATURE HAS FALLEN FROM ME. THERE ARE NO MORE BOOKS TO BE WRITTEN, THANK GOD. THIS
ORD. NO, THIS IS A PROLONGED INSULT, A GOB OF SPIT IN THE FACE OF ART, A KICK IN THE PANTS TO GOD, MAN, DESTINY, TIME, LOVE, BEAUTY...WHAT YOU WILL.
ARTIST. I NO LONGER THINK ABOUT IT, I AM. EVERYTHING THAT WAS LITERATURE HAS FALLEN FROM ME. THERE ARE NO MORE BOOKS TO BE WRITTEN, THANK GOD. THIS
ORD. NO, THIS IS A PROLONGED INSULT, A GOB OF SPIT IN THE FACE OF ART, A KICK IN THE PANTS TO GOD, MAN, DESTINY, TIME, LOVE, BEAUTY...WHAT YOU WILL.
ARTIST. I NO LONGER THINK ABOUT IT, I AM. EVERYTHING THAT WAS LITERATURE HAS FALLEN FROM ME. THERE ARE NO MORE BOOKS TO BE WRITTEN, THANK GOD. THIS
ORD. NO, THIS IS A PROLONGED INSULT, A GOB OF SPIT IN THE FACE OF ART, A KICK IN THE PANTS TO GOD, MAN, DESTINY, TIME, LOVE, BEAUTY...WHAT YOU WILL.
ARTIST. I NO LONGER THINK ABOUT IT, I AM. EVERYTHING THAT WAS LITERATURE HAS FALLEN FROM ME. THERE ARE NO MORE BOOKS TO BE WRITTEN, THANK GOD. THIS
ORD. NO, THIS IS A PROLONGED INSULT, A GOB OF SPIT IN THE FACE OF ART, A KICK IN THE PANTS TO GOD, MAN, DESTINY, TIME, LOVE, BEAUTY...WHAT YOU WILL.
ARTIST. I NO LONGER THINK ABOUT IT, I AM. EVERYTHING THAT WAS LITERATURE HAS FALLEN FROM ME. THERE ARE NO MORE BOOKS TO BE WRITTEN, THANK GOD. THIS
ORD. NO, THIS IS A PROLONGED INSULT, A GOB OF SPIT IN THE FACE OF ART, A KICK IN THE PANTS TO GOD, MAN, DESTINY, TIME, LOVE, BEAUTY...WHAT YOU WILL.
ARTIST. I NO LONGER THINK ABOUT IT, I AM. EVERYTHING THAT WAS LITERATURE HAS FALLEN FROM ME. THERE ARE NO MORE BOOKS TO BE WRITTEN, THANK GOD. THIS
ORD. NO, THIS IS A PROLONGED INSULT, A GOB OF SPIT IN THE FACE OF ART, A KICK IN THE PANTS TO GOD, MAN, DESTINY, TIME, LOVE, BEAUTY...WHAT YOU WILL.
ARTIST. I NO LONGER THINK ABOUT IT, I AM. EVERYTHING THAT WAS LITERATURE HAS FALLEN FROM ME. THERE ARE NO MORE BOOKS TO BE WRITTEN, THANK GOD. THIS
ORD. NO, THIS IS A PROLONGED INSULT, A GOB OF SPIT IN THE FACE OF ART, A KICK IN THE PANTS TO GOD, MAN, DESTINY, TIME, LOVE, BEAUTY...WHAT YOU WILL.
ARTIST. I NO LONGER THINK ABOUT IT, I AM. EVERYTHING THAT WAS LITERATURE HAS FALLEN FROM ME. THERE ARE NO MORE BOOKS TO BE WRITTEN, THANK GOD. THIS
ORD. NO, THIS IS A PROLONGED INSULT, A GOB OF SPIT IN THE FACE OF ART, A KICK IN THE PANTS TO GOD, MAN, DESTINY, TIME, LOVE, BEAUTY...WHAT YOU WILL.
ARTIST. I NO LONGER THINK ABOUT IT, I AM. EVERYTHING THAT WAS LITERATURE HAS FALLEN FROM ME. THERE ARE NO MORE BOOKS TO BE WRITTEN, THANK GOD. THIS
ORD. NO, THIS IS A PROLONGED INSULT, A GOB OF SPIT IN THE FACE OF ART, A KICK IN THE PANTS TO GOD, MAN, DESTINY, TIME, LOVE, BEAUTY...WHAT YOU WILL.
ARTIST. I NO LONGER THINK ABOUT IT, I AM. EVERYTHING THAT WAS LITERATURE HAS FALLEN FROM ME. THERE ARE NO MORE BOOKS TO BE WRITTEN, THANK GOD. THIS
ORD. NO, THIS IS A PROLONGED INSULT, A GOB OF SPIT IN THE FACE OF ART, A KICK IN THE PANTS TO GOD, MAN, DESTINY, TIME, LOVE, BEAUTY...WHAT YOU WILL.
ARTIST. I NO LONGER THINK ABOUT IT, I AM. EVERYTHING THAT WAS LITERATURE HAS FALLEN FROM ME. THERE ARE NO MORE BOOKS TO BE WRITTEN, THANK GOD. THIS
ORD. NO, THIS IS A PROLONGED INSULT, A GOB OF SPIT IN THE FACE OF ART, A KICK IN THE PANTS TO GOD, MAN, DESTINY, TIME, LOVE, BEAUTY...WHAT YOU WILL.
ARTIST. I NO LONGER THINK ABOUT IT, I AM. EVERYTHING THAT WAS LITERATURE HAS FALLEN FROM ME. THERE ARE NO MORE BOOKS TO BE WRITTEN, THANK GOD. THIS
ORD. NO, THIS IS A PROLONGED INSULT, A GOB OF SPIT IN THE FACE OF ART, A KICK IN THE PANTS TO GOD, MAN, DESTINY, TIME, LOVE, BEAUTY...WHAT YOU WILL.
ARTIST. I NO LONGER THINK ABOUT IT, I AM. EVERYTHING THAT WAS LITERATURE HAS FALLEN FROM ME. THERE ARE NO MORE BOOKS TO BE WRITTEN, THANK GOD. THIS
ORD. NO, THIS IS A PROLONGED INSULT, A GOB OF SPIT IN THE FACE OF ART, A KICK IN THE PANTS TO GOD, MAN, DESTINY, TIME, LOVE, BEAUTY...WHAT YOU WILL.
ARTIST. I NO LONGER THINK ABOUT IT, I AM. EVERYTHING THAT WAS LITERATURE HAS FALLEN FROM ME. THERE ARE NO MORE BOOKS TO BE WRITTEN, THANK GOD. THIS
ORD. NO, THIS IS A PROLONGED INSULT, A GOB OF SPIT IN THE FACE OF ART, A KICK IN THE PANTS TO GOD, MAN, DESTINY, TIME, LOVE, BEAUTY...WHAT YOU WILL.
ARTIST. I NO LONGER THINK ABOUT IT, I AM. EVERYTHING THAT WAS LITERATURE HAS FALLEN FROM ME. THERE ARE NO MORE BOOKS TO BE WRITTEN, THANK GOD. THIS
ORD. NO, THIS IS A PROLONGED INSULT, A GOB OF SPIT IN THE FACE OF ART, A KICK IN THE PANTS TO GOD, MAN, DESTINY, TIME, LOVE, BEAUTY...WHAT YOU WILL.
ARTIST. I NO LONGER THINK ABOUT IT, I AM. EVERYTHING THAT WAS LITERATURE HAS FALLEN FROM ME. THERE ARE NO MORE BOOKS TO BE WRITTEN, THANK GOD. THIS
ORD. NO, THIS IS A PROLONGED INSULT, A GOB OF SPIT IN THE FACE OF ART, A KICK IN THE PANTS TO GOD, MAN, DESTINY, TIME, LOVE, BEAUTY...WHAT YOU WILL.
ARTIST. I NO LONGER THINK ABOUT IT, I AM. EVERYTHING THAT WAS LITERATURE HAS FALLEN FROM ME. THERE ARE NO MORE BOOKS TO BE WRITTEN, THANK GOD. THIS
ORD. NO, THIS IS A PROLONGED INSULT, A GOB OF SPIT IN THE FACE OF ART, A KICK IN THE PANTS TO GOD, MAN, DESTINY, TIME, LOVE, BEAUTY...WHAT YOU WILL.
ARTIST. I NO LONGER THINK ABOUT IT, I AM. EVERYTHING THAT WAS LITERATURE HAS FALLEN FROM ME. THERE ARE NO MORE BOOKS TO BE WRITTEN, THANK GOD. THIS
ORD. NO, THIS IS A PROLONGED INSULT, A GOB OF SPIT IN THE FACE OF ART, A KICK IN THE PANTS TO GOD, MAN, DESTINY, TIME, LOVE, BEAUTY...WHAT YOU WILL.
ARTIST. I NO LONGER THINK ABOUT IT, I AM. EVERYTHING THAT WAS LITERATURE HAS FALLEN FROM ME. THERE ARE NO MORE BOOKS TO BE WRITTEN, THANK GOD. THIS
ORD. NO, THIS IS A PROLONGED INSULT, A GOB OF SPIT IN THE FACE OF ART, A KICK IN THE PANTS TO GOD, MAN, DESTINY, TIME, LOVE, BEAUTY...WHAT YOU WILL.
ARTIST. I NO LONGER THINK ABOUT IT, I AM. EVERYTHING THAT WAS LITERATURE HAS FALLEN FROM ME. THERE ARE NO MORE BOOKS TO BE WRITTEN, THANK GOD. THIS

Design Stefania Malmsten Bibel No. 5, 1999 Swedish fashion magazine, a modern classic
Bibel No. 12, 1999

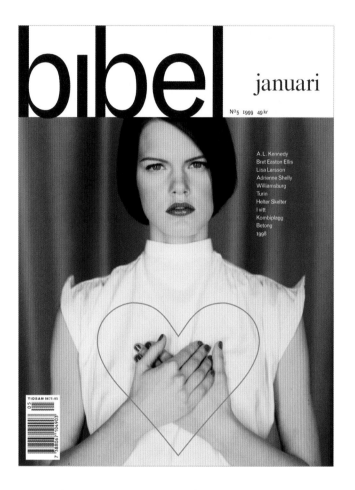

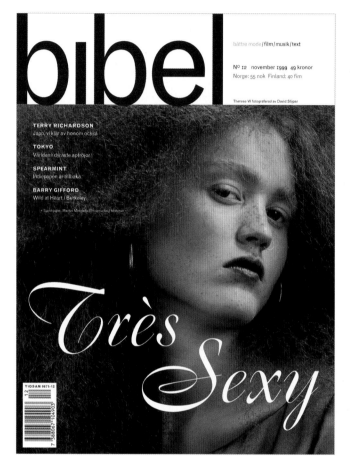

Design	Jan Nielsen	Winthers Wonderworld	Book displaying Pierre Winther's photographic work
	Ole Lund		
Photography	Pierre Winther		

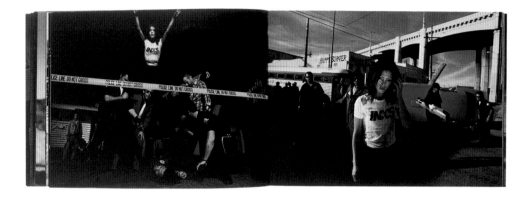

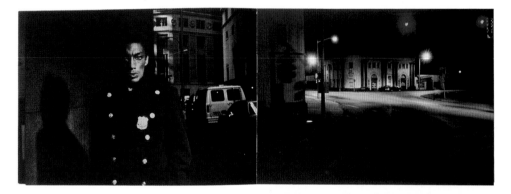

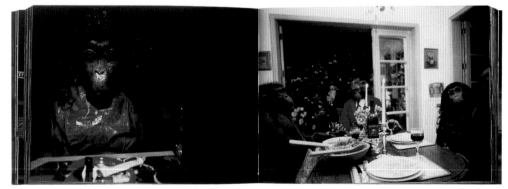

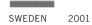

Design	StyleWar	Main Offender	Music video for Swedish band The Hives
Photography	David Hellman		

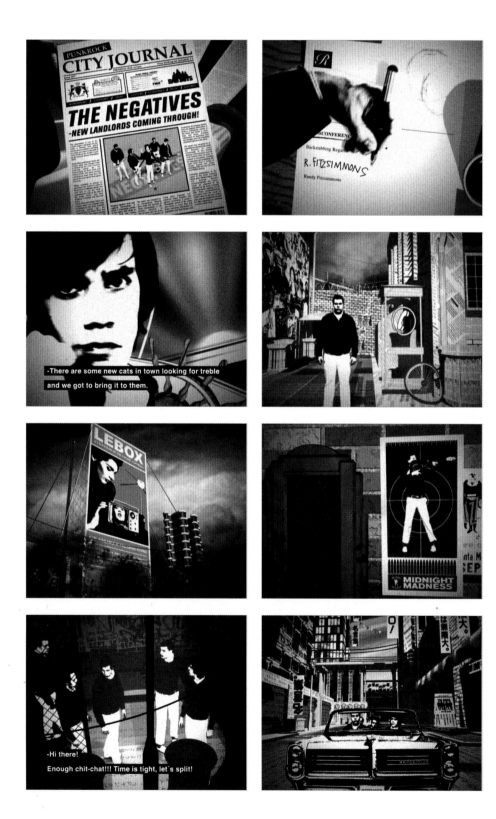

Morning Glory Motion graphic identity for the MTV show Morning Glory
Up North Motion graphic identity for the MTV show Up North

| **Design** | Gudmundur Oddur Magnusson | TYFT | Promotional posters for avant-garde jazz musician Hilmar Jensson |
| **Photography** | Gudmundur Oddur Magnusson | | |

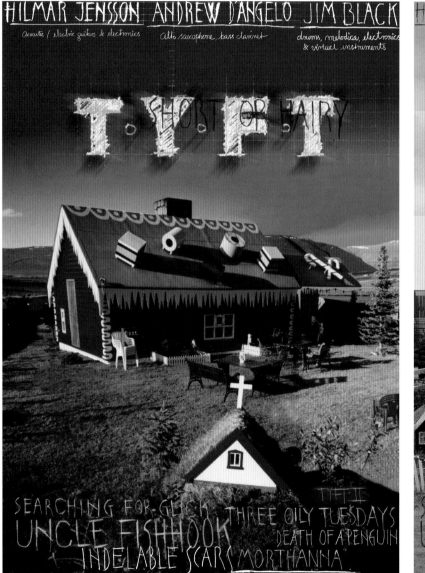

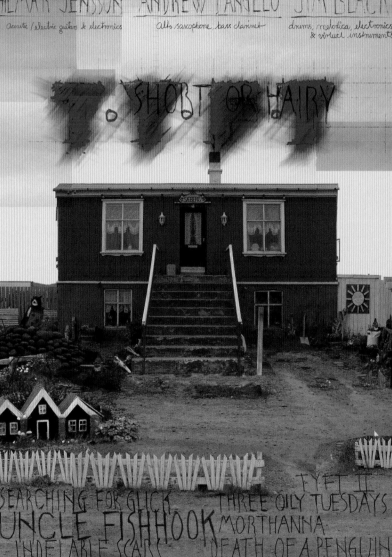

Traust CD designs for Badtaste's Icelandic Contemporary Jazz series
Kjar
Crucible

Við kynnum *Herra & Ungfrú Reykjavík sem Stefán Kjartansson og RXC* hafa hannað. Letrið er selt hjá *Psy/Ops®* San Francisco, CA. Heimsækið <www.psyops.com> eða hringið í 001-415-896-5788 til að fá nánari upplýsingar. Íslensk framleiðsla.

Introducing *Mr. & Ms. Reykjavik.* From the reciprocating drawing board of Stefán Kjartansson & RXC. Fonts available exclusively from *Psy/Ops®* San Francisco. Visit <www.psyops.com> or call 1.888.PSY-FONE toll free (US) for more information. Product of Iceland

AAAAAAAA**AA**AA*AAAA*BBBB**B**BB*BBB*
CCCCCCCC**CCC**C*CCCC*DDDD**D**DD*DDDD*
ĐĐ**Đ**ĐĐ*ĐĐĐ*EEEE**E**EE*EEE*ƐƐƐƐ*ƐƐƐƐ*
FF**F**FFFF*G*GG**G**GG*GGGG*GG*GGGG*
HHHH**H**HHHH*HH*IIII**I**II*IIII*JJJJ**J**JJ*JJJJ*KKKK**K**
KK*KK***KKK**KKKK*LLLL**L**MMMM**M**MM*MMM*
NNNN**N**NN*NN*OOOO**O**OO*OOOO*PPPP**P**PP*PP*
QQQQ**Q**QQ*QQ***QQQQ**Q*QQQ*RRRR**R**RR*RRR*
SSSS**S**SS*SSS*TTTT**T**TT*TTTT*UUUU**U**UU*UUUU*
VVVV**V**VV*VVV*WWWW**W**WW*WWW*XXXX**X**XX*XXX*
YYYY**Y**YY*YYYZ*ZZZ**Z**ZZ*ZZZZ*ÞÞ**Þ**ÞÞ*ÞÞÞ*

ÆÆÆÆ**Æ**ÆÆ*ÆÆÆ*ÆÆ**ÆÆ**FE*Æ*FÆ***Æ***Æ*
ÖÖÖÖ**Ö**ÖÖ*ÖÖÖ*&&&**&***&***&*&*&****&***€Đ€€*@@@*@*
aaaa**a**aa*aaa***aaaa**aa*aaa*bbbb**b**bb*bcccc*
cccc dddd**d**dd*dddd***d*ddd*ðĐð**ð**ðð*ðÐ*
eeee**e**ee*eee***e***e**e*ffff*ffff**ff*ffff*f*gggg*
*gggg*gg**g**gg*gggg*hhhh**h**hhhh*hii*ii**ii*iiii*jjj*
jjjj*kkkk**k**kk*kk*kk**k***kkkk*IIII**I**IIII***mmmm*
*mmmm*nnn**n**nn*oooo**o**oo*oooo*pppp**p**pp*pppp*
qqq*q**q**qqq*qqq**qqq**rrrr**r**rr*rrssssss***s*
tttt**t**tt*tttt***t*tttt*uuu**u**uuuu*vvvv**v**vv*vvv*
wwww**w**ww*www*xxxx**x**xx*xxx*yyyy**y**yy*y*yy*y*
*yyyy*yyyy*zzzz**z**zz*zzzz*þ*þþ***þ**þþ*þþ*þ*ææ*ææ*
ææ**æ**æ*æ*æ***æ***ææ**æ*öööö***ö**öö*ööö*1111*2222*
3333**3**4444*5555**5**6666**6**777**7**788*8**8**9*
9990000**0**åååå***å**??**?**??**?**!!!!!***£***£**£*ß*ßß*ßß*”””“““*ØØØ*

REYKJAVIK
ReykjavikOne (Herra) – AGauge

REYKJAVIK
ReykjavikOne (Herra) – BGauge

REYKJAVIK
ReykjavikOne (Herra) – CGauge

REYKJAVIK
ReykjavikOne (Herra) – DGauge

REYKJAVIK
ReykjavikOne (Herra) – AGauge Italic

REYKJAVIK
ReykjavikOne (Herra) – BGauge Italic

REYKJAVIK
ReykjavikOne (Herra) – CGauge Italic

REYKJAVIK
ReykjavikOne (Herra) – DGauge Italic

REYKJAVIK
ReykjavikTwo (Ungfrú) – AGauge

REYKJAVIK
ReykjavikTwo (Ungfrú) – BGauge

REYKJAVIK
ReykjavikTwo (Ungfrú) – CGauge

REYKJAVIK
ReykjavikTwo (Ungfrú) – DGauge

REYKJAVIK
ReykjavikTwo (Ungfrú) – AGauge Italic

REYKJAVIK
ReykjavikTwo (Ungfrú) – BGauge Italic

REYKJAVIK
ReykjavikTwo (Ungfrú) – CGauge Italic

REYKJAVIK
ReykjavikTwo (Ungfrú) – DGauge Italic

SUBTOPIA PERSONAL PROJECT NORWAY 2002

Design Subtopia Cleanfax Promotional material for Subtopia's Cleanfax typeface

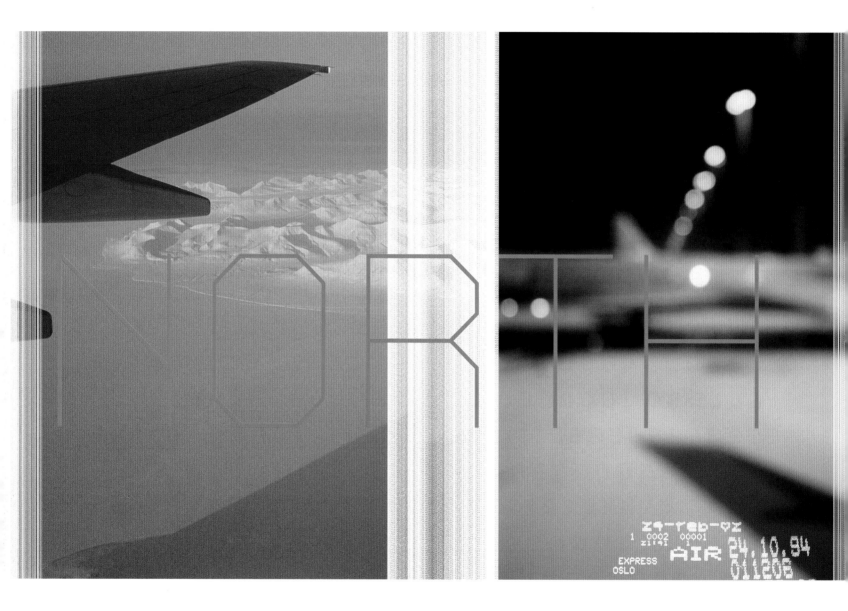

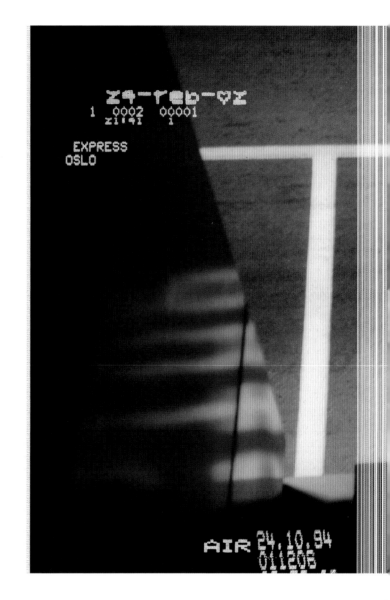

STOCKHOLM DESIGN LAB

Design	Stockholm Design Lab	SAS Graphic Profile	Complete overhaul of the SAS corporate identity programme
Art Direction	Stockholm Design Lab		Rethink of how to display SAS values graphically in every aspect
Creative Direction	Stockholm Design Lab		of communication, from airplanes down to the smallest details
Photography	Gösta Reiland		

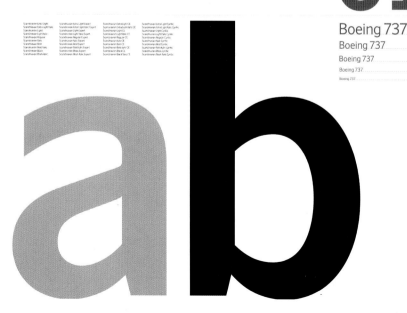

Scandinavian

AaBbCcDdEeFfGgHhIiJjKkLlMmNnOoPpQqRrSsTtUu
VvWwXxYyZz1234567890(&.,:?!)§$£€™
Scandinavian Extra Light

AaBbCcDdEeFfGgHhIiJjKkLlMmNnOoPpQqRrSsTt
UuVvWwXxYyZz1234567890(&.,:?!)§$£€™
Scandinavian Light

AaBbCcDdEeFfGgHhIiJjKkLlMmNnOoPpQqRrSsTt
UuVvWwXxYyZz1234567890(&.,:?!)§$£€™
Scandinavian Regular

**AaBbCcDdEeFfGgHhIiJjKkLlMmNnOoPpQqRrSs
TtUuVvWwXxYyZz1234567890(&.,:?!)§$£€™**
Scandinavian Bold

01

Boeing 737
Boeing 737
Boeing 737
Boeing 737
Boeing 737

ab

Design	Petra Bengtson	Junges Schwedisches Design	Poster for the Bauhaus museum, Berlin
Art Direction	Björn Kusoffsky		
Creative Direction	Björn Kusoffsky		
Photography	Lennart Nilsson		

CHRISTIAN ZANDER

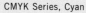
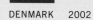

Design Christian Zander
 Rune Brink Hansen

CMYK Series, Cyan Hand-stencilled, non-commercial, public design project

The project examines anonymous public communication
and the mutation of its message and through time

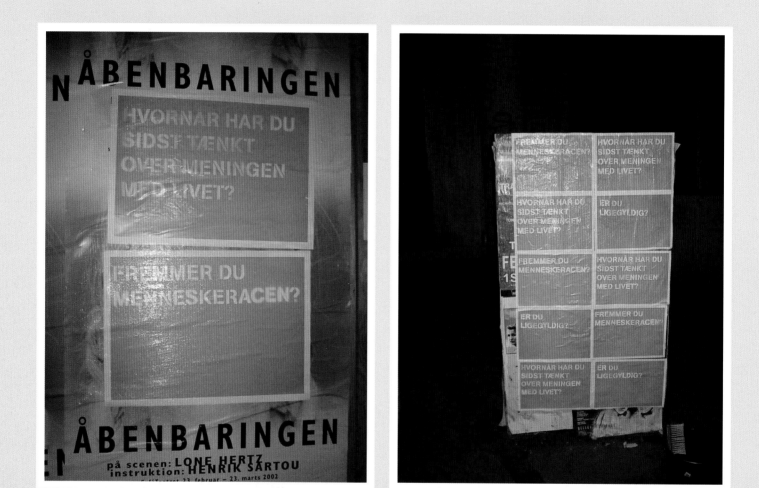

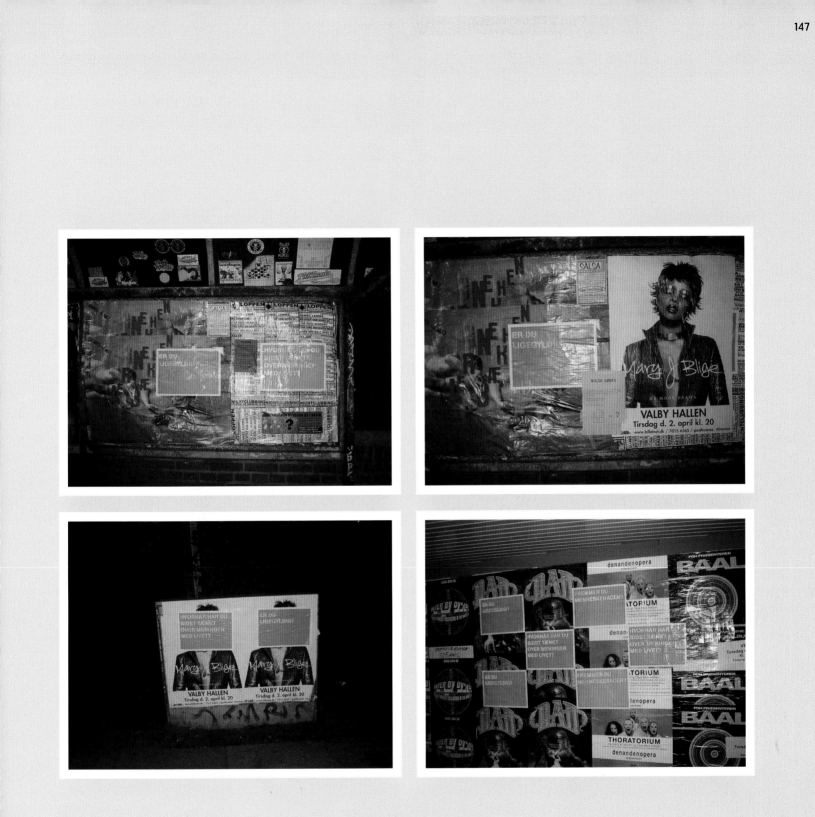

2GD

2GD INTERNAL

DENMARK 2000

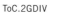

Design	Jan Nielsen
	Ole Lund
Photography	Soeren Nielsen
Text	Soeren Soenderstrup

ToC.2GDIV

Book project, introduction to the strategy of aesthetic creation....

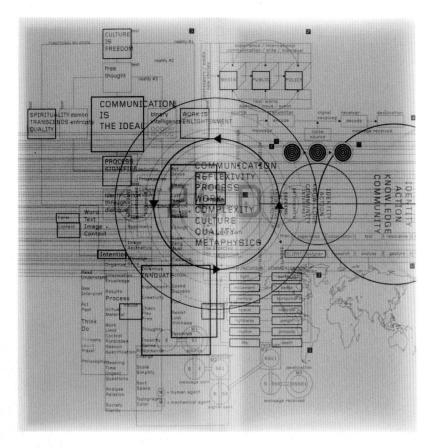

WORK
IS
ENLIGHTENME

SPIRITUALITY
TRANSCENDS
QUALITY

WORK
IS
ENLIGHTENMENT

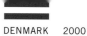
Design e-Types Munthe + Identity and promotional material for this Danish fashion brand
Photography Eva Lotta Persson
 Torben Eskerod
 Susanne Weiim

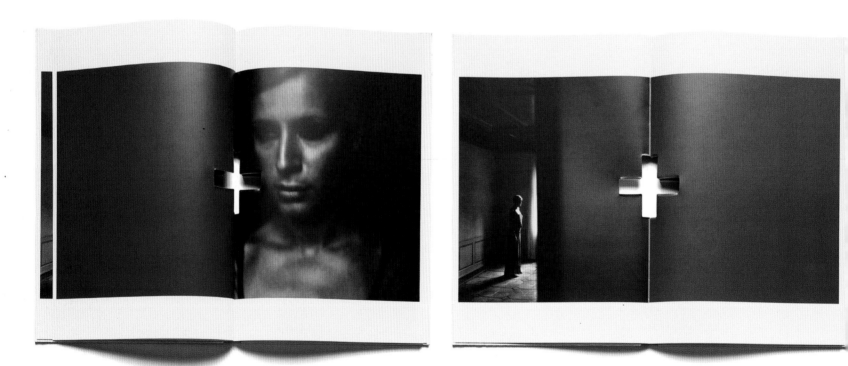

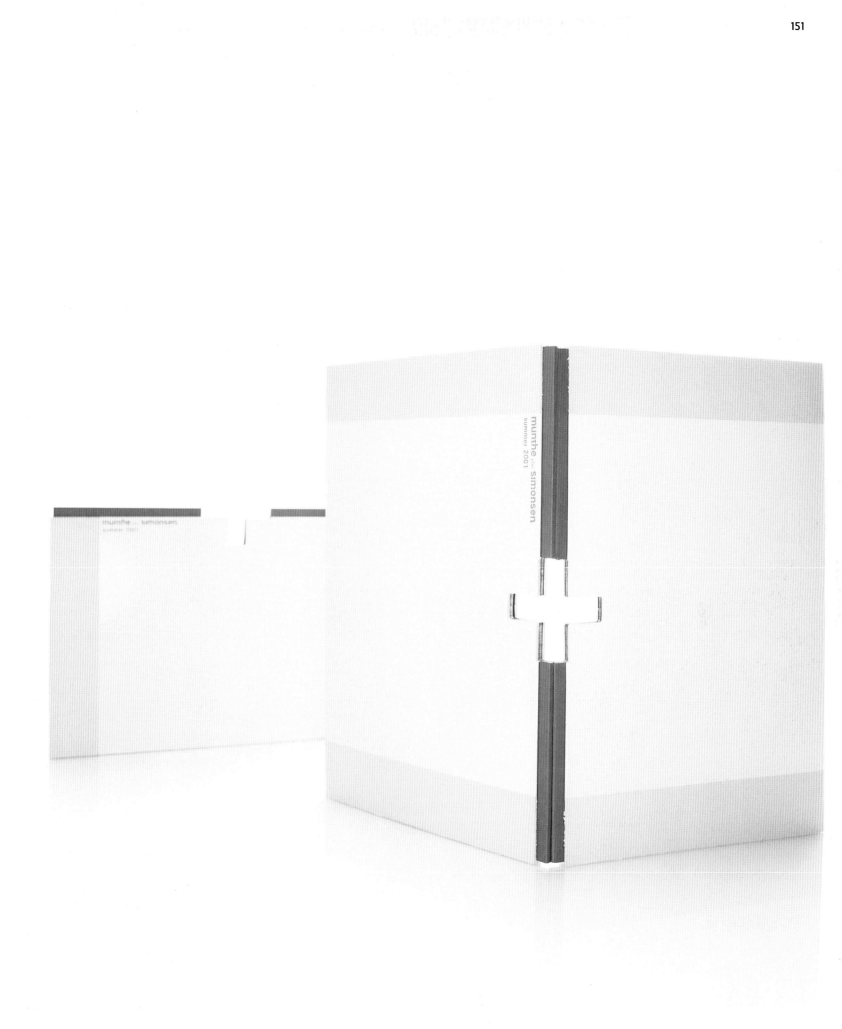

■ **Design** Markus Moström Small Calendar Part of design programme developed for the
architects Claesson Koivisto Rune

Design Sweden
Photography Louise Billgert

Pocky Books

Latest graphic profile for Pocky books, paperback series

AMERICA VERA-ZAVA

GLOBAL RÄTTVISA ÄR MÖJLIG

Global rättvisa är möjlig är en unik bok. Den erbjuder nämligen två alternativa förklaringar till varför 1,2 miljard i världen idag är extremt fattiga, vilka som har makten att förändra de rådande förhållandena och vad som kr ska bli mer rättvis. Vänder du på boken finner du att Johan Norberg, liberal debattör verksam vid tankesmed som författare. Från det här hållet är det America Vera-Zavala, frontfigur i *Attac* och *Ung Vänster*, som redogö

SCANDINAVIAN DESIGN GROUP **PRICE WATERHOUSE COOPERS** DENMARK 2002

Design	Muggie Ramadani	Image Brochure	Image and text booklet presentation
Photography	Simon Ladefoged		
Text	Signe Duus		

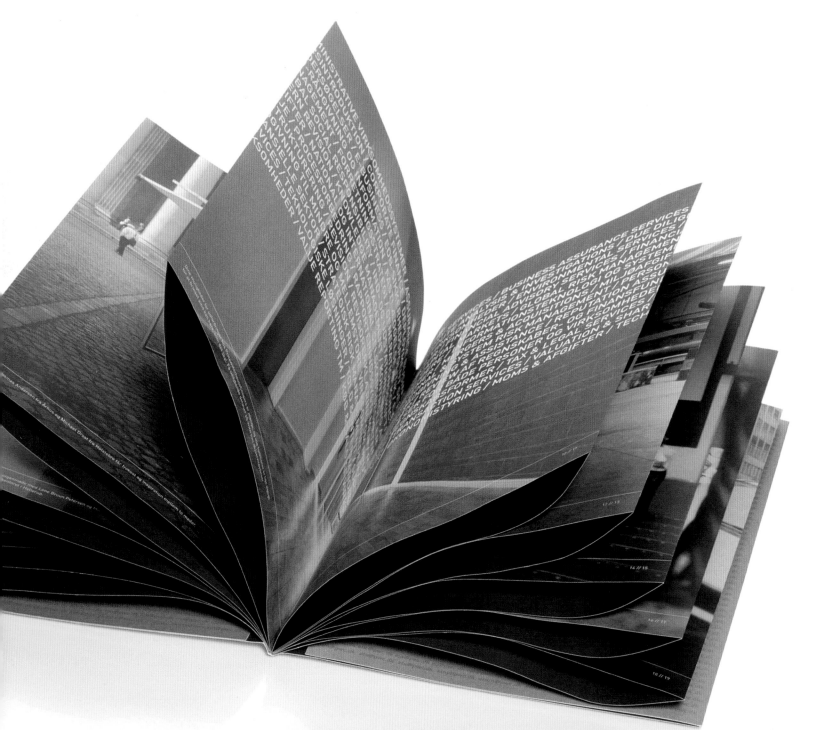

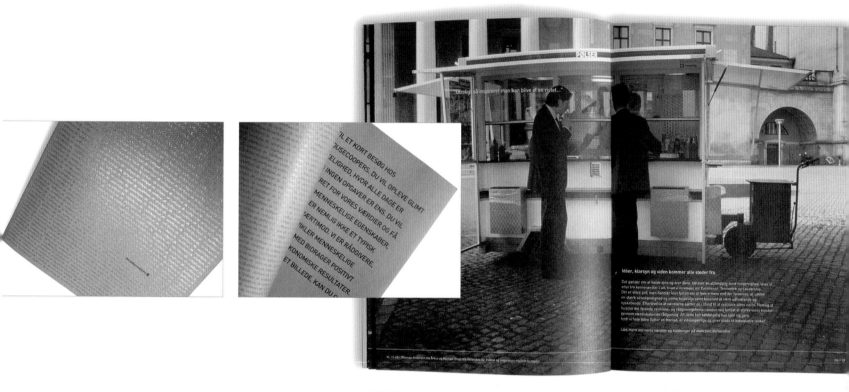

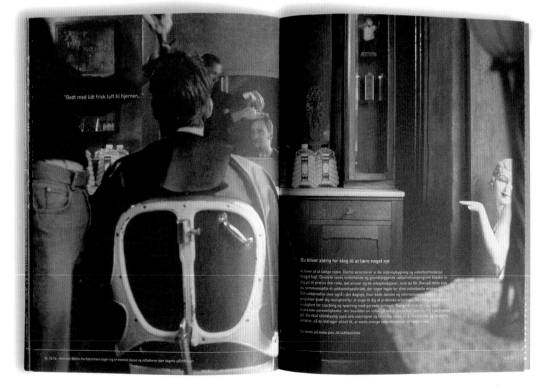

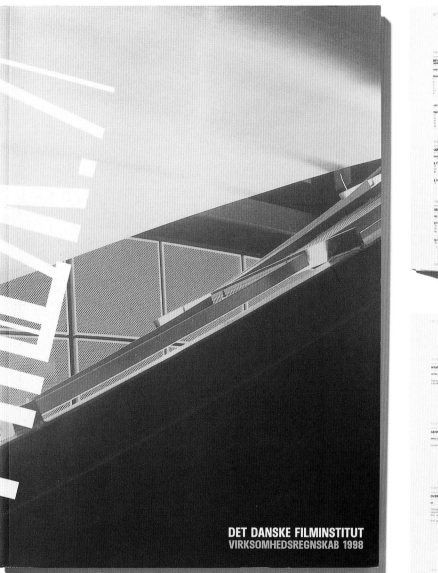

Film No. 5, 1999 Monthly magazine published by The Danish Film Institute
Film No. 17, 2001

TIL LYKKE COWBOY!

Nej, FILM *05 er ikke et temanummer om Westerns. Billedet fra *The Searchers* er til ære for Niels Jensen, hvis viden og engagement har inspireret generationer af danske filmfolk. Jensen fyldte 70 år den 12. november.

SIDE 2

DIGITALT BILLEDDEMOKRATI

Low Res - film med lav billedopløsning distribueret via Internettet - er ikke kun et nyt stykke legetøj for technodrenge. I fremtiden kan alle i princippet producere deres egne film og distribuere dem til hele verden.

SIDE 7

EUROPA CINEMAS

Biografvisning af europæiske film har i årevis været under pres fra den velsmurte amerikanske underholdningsmaskine. Det er der nogen, der gør noget ved, med støtte fra EU's medieprogram *Europa Cinemas*.

SIDE 16

FILM UDGIVES OG DISTRIBUERES AF DET DANSKE FILMINSTITUT / NOVEMBER 1999

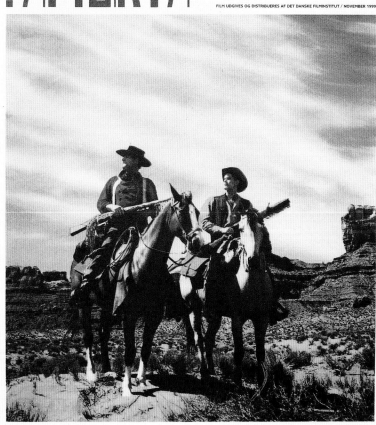

LÆRERIGT

"Mange ting, som fungerer på papiret, fungerer ikke, når det bliver til virkelighed, og det er enormt lærerigt at se det spring." Anders Thomas Jensen om novellefilm som sin filmskole.

SIDE 3

FRIRUM

"Novellefilm er et sted, hvor filmfolk kan skærpe deres værktøj uden et kommercielt pust i nakken." Carsten Sønder og Helle Winther, Novellefilms daglige ledelse.

SIDE 8

DRAMATURGI

"På en eller anden måde kan man næsten ikke nå at fortælle historien i en novellefilm. Man skal få plottet til at blive så simpelt, at det næsten forsvinder." Mogens Rukov om novellefilmen.

SIDE 20

FILM UDGIVES OG DISTRIBUERES AF DET DANSKE FILMINSTITUT / AUGUST 2001

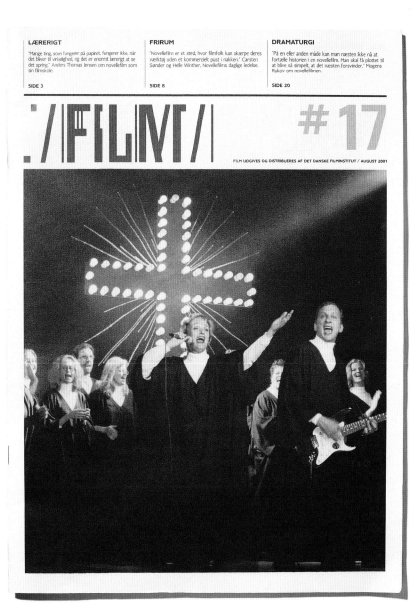

Magazine Staff Tuukka Kaila Numero'zine Covers and spreads from an independent skateboard magazine
Timo Hyppönen
Mikko Kempas
Juho Huttunen

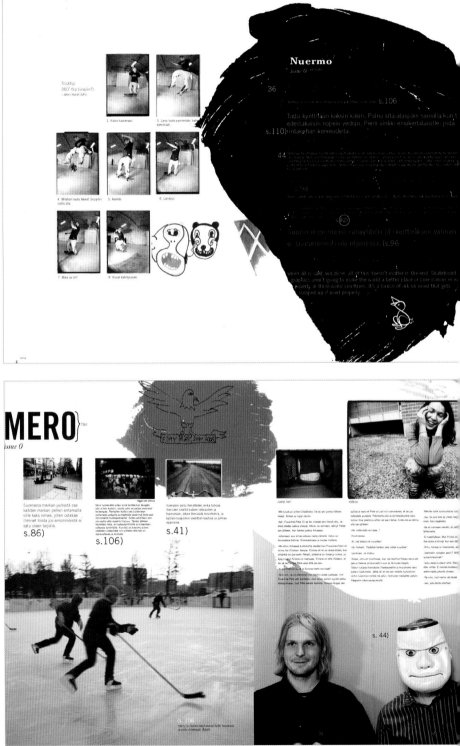

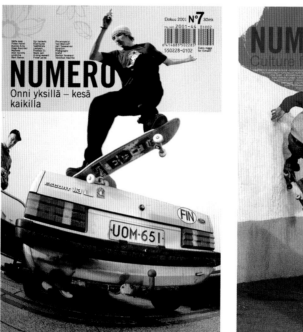

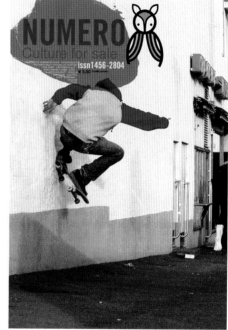

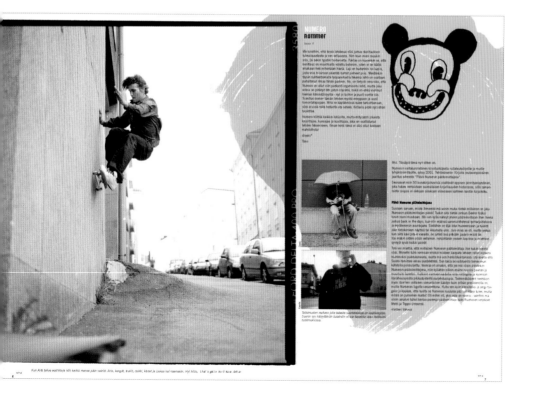

Design Einar Gylfason Fitfrettir Newsletter from FIT, Association of Icelandic Graphic Designers

fitfréttir

Margur félaginn í FÍT hefur spurt sig ýmissa spurninga varðandi tilvist og starfsemi félagsins og ekki síður þeir sem eru að hugleiða að gerast félagar í FÍT. Hvað gerir þú? Er einhvers virði að vera félagi í FÍT? Það hefur að minnsta kosti aldrei vafist fyrir undirrituðum að svara þessari spurningu. Ég er fullviss um að flestir þeir félagar FÍT sem hafa verið það í einhvern tíma geta svarað því fullum hálsi, hvers virði það er að vera félagi og hvers virði er fyrir hugsandi teiknara. Ef þeir eiga ekki orð yfir það, hafa þeir að minnsta kosti sterka tilfinningu fyrir því. Hvað ef það væri ekki til? Ég held að „teiknarasamfélagið" væri fátækara og mér liggur við að segja munaðarlausara ef FÍT geispaði golunni. Þótt félagið hafi farið í gegnum hæðir og lægðir, hefur ekkert komið sem leysir það af hólmi sem vettvang til samskipta og símenntunar á sviði grafískrar hönnunar. En FÍT sér ekki um sig sjálft og verður ekki til úr engu. Því er stjórnað af félögum þess og þeir ráða lífsmarkinu því hverju sinni. Hlutverk FÍT breytist ekki. Það fylgist

með til að geta haldið hlutverki sínu og tíðarandinn á alltaf að vera félaginu hagstæður. FÍT verður á hverjum tíma að gera sig gildandi og áhugavert og getur ekki reitt sig eingöngu á velvild og væntumþykju gamalla félaga. Það er því ánægjulegt að með nýjum ungum stjórnarmönnum koma nýir félagar. FÍT félagar eru vel yfir tvö hundruð og kynjaskipting er nokkuð jöfn. Á undanförnum árum hefur FÍT staðið fyrir innflutningi á erlendum fyrirlesurum. Má þar nefna, Stefan Sagmeister, Wolfgang Weingart, David Carson og Paul Arden. Allt einstaklingar sem hafa haft áhrif víða um heim með starfi sínu og hugmyndum. Heimsóknir þeirra hafa glatt anda fagsins hér og hvatt teiknara til metnaðarfyllri verka. Kornhlöðufundir hafa verið haldnir reglulega, þar sem félagar hittast og ræða málin. Þar hafa einstakir félagsmenn kynnt verk sín eða málefni varðandi fagið okkar, tekin fyrir og >>

kynnt. Þá hefur FÍT staðið fyrir sýningum á verkum félaga sinna og var það árlegur viðburður sem vert er að taka upp á ný og setja á fasta dagskrá. Á þessum sýningum voru tekin fyrir ýmis þjóðfélagsleg eða sammannleg málefni sem ekki var fjallað um á sjónrænum vettvangi hönnunar annars staðar. Trú, ofbeldi og umhverfismál, svo nokkuð sé nefnt. Fréttabréf með því sem hefur verið að frétta í félaginu er dreift til félagsmanna 2-3 sinnum á ári. Merkjasamkeppnir sem vilja vera faglegar og leitað er eftir tillögum fagfólks, hafa innanborðs FÍT félaga í meirihluta dómnefndar. Ein slík keppni er einmitt kynnt í þessu fréttabréfi. Með aðkomu FÍT hefur verðlaunafé til teiknara verið tryggt. Höfundarréttarmál verða sífellt meira áberandi og það er aðkallandi að þeim sé sinnt í okkar félagi þar sem miklir hagsmunir geta verið í húfi. Sérstaklega gagnvart myndskreytum og öðrum félagsmönnum sem telja að verk sín séu fjölfölduð og notuð umfram heimildir. Í Myndstefi sem fer með málefni höfundarréttar, á FÍT rétt á stjórnarmanni. Það sama má segja um Form Ísland, en FÍT er aðili að sameiginlegu starfi hönnunarfélaga í landinu. Þá eru ótalin alþjóðleg félög sem íslenskir teiknarar hafa aðgang að í gegnum FÍT. Nú í mars síðastliðnum varð að veruleika sú hugmynd sem lengi hefur verið rædd, að taka upp sérstök

verðlaun, fyrir bestu og áhugaverðustu verk félagsmanna FÍT á árinu. Þeim eru gerð betri skil hér annars staðar í fréttabréfinu og FÍT verðlaunin verða væntanlega árviss viðburður héðan í frá. Til þeirra er stofnað til að gera FÍT félaga enn betur hugsandi um gildi góðra verka, berjast gegn stöðnun og geta verið vettvangur þar sem djörfum hugmyndum og vönduðum vinnubrögðum er haldið á lofti. Skemmtanir, árshátíðir og uppákomur aðrar hafa síðan fylgt félaginu á hverjum tíma. Eins og fyrr segir er hlutverk FÍT fyrst og fremst að glæða og viðhalda faglegum metnaði félaga sinna, stuðla að því að verk þeirra verði eftirsótt og starf FÍT félaga allra verði meira krefjandi og gefandi. Þetta er í örstuttu máli hvað FÍT hefur verið að gera og á að standa fyrir. Breytingar krefjast endurskoðunar og nýrra leiða til að viðhalda góðum árangri. Síðasti aðalfundur FÍT, sem haldinn var í Kornhlöðunni 28. febrúar, skipaði nýja stjórn sem hefur undanfarna mánuði skipt með sér verkum og vinnur nú hratt að fjölbreyttum málum til að gera FÍT að enn sterkari bakhjarli okkar sem höfum áhuga á grafískri hönnun og hugmyndasmíði. Um margt af því má fá fréttir af hér á síðunum. Eins og þeir segja sem ekki fóru í málhreinsunarátakið, „Stay tuned". ÁJ

MERKI FYRIR LANDSMÓT UMFÍ

Ungmennafélag Íslands (UMFÍ) efnir til samkeppni um gerð nýs merkis fyrir Landsmót UMFÍ í samvinnu við FÍT. Merkinu er ætlað að vera framtíðartákn landsmóta UMFÍ. Verðlaun fyrir bestu tillöguna að mati dómnefndar eru 350.000 kr. auk þess sem greiddar verða 150.000 kr. fyrir útfærslu merkis og reglur um notkun. Dómnefnd er skipuð 5 fulltrúum, 2 frá UMFÍ og 3 frá FÍT. Frestur til að skila inn tillögum er til 8. júní 2001. Tillögum skal skila undir dulnefni til: UMFÍ, Landsmótsmerki, Fellsmúla 26, 108 Reykjavík. Dulnefni skal fylgja með í lokuðu umslagi. Tillögur skulu vera á A4 blaði, í lita- og svarthvítri útgáfu. Landsmótsmerkið verður notað á bréfsefni og pappíra, boli, fána, veifur, minjagripi, verðlaunagripi, byggingar o.fl. Allar nánari upplýsingar um samkeppnina eru veittar á skrifstofu UMFÍ í síma 568 2929.

Nánari upplýsingar um UMFÍ og Landsmótin er að finna á heimasíðu UMFÍ, www.umfi.is.

VORHÁTÍÐ Í HLAÐVARPANUM

FÍT félagar fögnuðu vori og kvöddu vetur í salsasveiflu í Hlaðvarpanum og drukkið a la latino frábært tapas sem átti vel við. Flamenco sveitarinnar Felicidae. Actionarykeppni var eitt af heimatilbúnu veislugestir glímdu við að geta upp á lögóurn sem félagar þeirra Íslenskrar erlbagreiningar eða Skifunnar? Það vita þeir sem ske og tóku þátt í spennandi keppni. Hinir hugsa sinn gang og kom

...eppni meðal félagsmanna. Þema keppninnar er „SAMFÉLAGIÐ SEM VIÐ
...sem rúmar margskonar hugsun og tjáningu: umhverfið, landið, þjóðfélagið,
...iguna, fólkið. Nánast allt, gott og vont, sem við teljum að skipti máli
...á á gagnsæ, sterk og rökföst skilaboð. Grafísk útfærsla er nokkuð frjáls;
...eða hvort tveggja. Æskilegt er þó að taka tillit til einföldunar í litanotkun
...amhlið bola og getur teiknarinn valið um svartan eða hvítan bol í stærð
...Allir innsendingar verða settar á boli (transfer efni) en
...lir til prentunar í takmörkuðu magni, þ.e. einn „Besti,
...og fjórir „Bestu bolir". Skilafrestur er til 8. júní nk.
...r dagana 15. til 25. júní. Allir bolirnir verða þá til sýn-
...gluggum við Bankastræti nr. 5, nr. 7 (Verslun Sævars
...lús málarans) og niður með Ingólfsstræti, gefi þátttaka
...kugjald er kr. 500 pr. bol og heimilt er að senda inn
...ögu. Dómnefnd skipa: Dagur Hilmarsson, teiknari FÍT
...ð formaður dómnefndar. Þórdís Claessen, teiknari FÍT
...sid.is). Halla Helgadóttir, teiknari FÍT (halla@fiton.is).
...kppninnar er Smári Gíslason, teiknari FÍT (smari@nm.is)
...lausnir (Freehand/Illustrator) sendast til hans. Aðal
...pppninnar er Bolur hf. Við þökkum þeim ásamt Sævari
...álarans góða og lipra samvinnu. Tökum nú sem flest
...átæki og látum ljós okkar skína. Búum til skemmtilega
...astræti yfir þjóðhátíðina og sýnum almenningi sköpunar-
...aaraftl.

NEW YORK

Í haust er fyrirhugað að skreppa í FÍT ferð til New York og skoða í fjóra
...nai. Borðað daga hvað heimsborgin hefur að bjóða grafískum hönnuðum. Hugmyndin
...ðöna hljóm- er að tengja ferðina við ráðstefnu sem byggir á margvíslegum fyrirlestrum
...ins, þar sem hönnuða og fólks sem starfar í tengslum við þá. Tímasetningin er seinni
...ar merki hluti nóvember nk. Gert er ráð fyrir að flogið sé út á fimmtudegi og
...rpanum komið heim að morgni þriðjudags. Frekari upplýsingar eru veittar hjá
...hátíð FÍT. salmo@islandia.is.

FÉLAGSGJÖLDIN

Það hefur viljað brenna við að félagsgjöld innheimtist misjafnlega
gegnum tíðina hjá FÍT félögum. En það er, eins og allir vita, undirstaðan
undir starfi félagsins að einhverjar krónur séu til í sjóði til að framkvæma
og undirbúa aðgerðir í þágu félaganna. Stjórn FÍT er að vinna þessa
dagana að nýju greiðslufyrirkomulagi á félagsgjöldum. Það verður fyrir
þeim hætti að nú býðst félögum að greiða í gegnum Visa eða Mastercard.
Þetta er til mikils hagræðis fyrir FÍT þar sem útsending gíróseðla hefur
aukakostnað í för með sér auk þess sem þeir hafa tilhneigingu til að
týnast í skúffum. Það er von FÍT að félagar taki þessari nýbreytni vel.
Félagsgjald er óbreytt kr. 5000 og gefst kostur á að greiða það í tvennu
lagi með korti. Málið verður nánar skýrt í bréfi sem allir FÍT félagar fá
á næstu vikum, en skriflegt samþykki þarf frá hverjum félaga í FÍT til
þess að fyrirkomulag þetta virki.

NÝ STJÓRN FÍT

Á aðalfundi FÍT sem haldinn var í febrúar var kosin ný stjórn. Stjórnin er skipuð til eins
árs og voru eftirfarandi kjörnir: Haukur Már Hauksson, Þórhallur Gunnarsson, Ágústa
Guðmundsdóttir, Haukur Haraldsson, Örn Smári Gíslason, Einar Gylfason, Sigrún
Gylfadóttir, Snæfríð Þorsteins, Jón Ágúst Pálmason, Hilmar Þorsteinsson
og Ástþór Jóhannsson.

Við skipulagningu þessarar
fyrstu keppni var ákveðið að
hafa bara fimm flokka til að
auðvelda framkvæmdina. Flokk-
arnir voru: Bókakápur, plötuum-
slög, vöru- og firmamerki, vegg-
spjöld og bréfagögn en í þeim flokki
voru möppur, ársskýrslur, bréfsefni
og bæklingar. Á næsta ári verða
flokkarnir fleiri þó ekki sé búið að
ákveða endanlega hverjir þeir verða.
24 manna dómnefnd, blandaður hópur
eldri og yngri hönnuða, dæmdi innsend-
ingarnar. Í dómnefnd voru: Aðalbjörg
Þórðardóttir, Agnar Tr. Le'macks, Ámundi
Sigurðsson, Björn B. Björnsson, Björn H.
Jónsson, Björn Jónsson, Garðar Pétursson,
Gísli B. Björnsson, Guðmundur Oddur Magnús-
son, Halla Guðrún Mixa, Halldór Elvarsson,
Halldór Baldursson, Hany Hadaya, Hilmar
Sigurðsson, Jakob Jóhannsson, Kristín Þóra
Guðbjartsdóttir, Kristín Ragna Gunnarsdóttir,
Kristín Þorkelsdóttir, Ólöf Birna Garðars-
dóttir, Sigrún Gylfadóttir, Stefán
Snær Grétarsson, Steingrímur
Eyfjörð, Tryggvi T. Tryggva-
son og Valgerður Guðrún
Halldórsdóttir.

HÖNNUNARVERÐLAUN FÍT 2001

Hönnunarverðlaun FÍT voru
afhent í fyrsta sinn föstudaginn
9. mars í Ásmundarsafni við
Sigtún. Það hefur lengi verið
talað um að halda sérstaka
hönnunarkeppni fyrir félags-
menn FÍT en ekkert orðið af
framkvæmd fyrr en nú að
ákveðið var að slá til. Viðbrögð
við keppninni voru mjög góð og
bárust yfir 120 innsendingar
í fimm flokka. Greinilegt var á
ummælum fólks og áhuga að
það var mjög ánægt með að
loksins skyldi vera haldin keppni
þar sem eingöngu fag-
menn sátu í dómnefnd
og dæmdu verkin
á faglegum
forsendum.

FÍT VEFURINN

Vefsvæði FÍT (loremipsum.is) fer
nú að líta dagsins ljós. Þar verður hægt
að sýna verk sín og sjá verk annarra. Þar
verður gagnrýnin sýn á auglýsingar og grafíska
hönnun. Opin spjallrás um málin frá degi til
dags. Tengingar inn á áhugaverðar vefslóðir og
fleira sem gerir grafíski hönnun gott. Sérstakur
kynningarhluti um FÍT verður öllum opinn,
en vefsvæðið í heild sinni verður aðeins
opið félögum í FÍT með sérstöku
aðgangsorði.

**Eftirfarandi fengu Hönnunarverðlaun
FÍT 2001**

Plötuumslög: Karl Örvarsson fyrir plötuna
Best með Todmobile.

Vöru- og firmamerki: Kristín Þóra Guð-
bjartsdóttir fyrir STOP, merki herferðar
Sambands íslenskra tryggingafélaga gegn
ölvunarakstri.

Bókakápur: Hunang/Sigrún Sigvaldadóttir
fyrir bókina Hnattflug.

Bréfagögn og bæklingar: Gréta V. Guð-
mundsdóttir fyrir „Make it" - kynning-
arbæklingi/uppskriftabók fyrir dönsku
auglýsingastofuna Kunde & Co.

Eftirfarandi fengu viðurkenningar

Plötuumslög: Guðrún le Sage de Fontenay
fyrir margmiðlunardiskinn Dimon - Waporizer
2.0 og Karl Örvarsson og Pétur Baldursson
fyrir plötuna „The soul of the great viking."

Vöru- og firmamerki: Soffía Árnadóttir fyrir
merki Ljósmyndasafns Reykjavíkur og
Aðalbjörg Þórðardóttir fyrir merki Íslenskrar
erfðagreiningar.

Bókakápur: Ólöf B. Garðarsdóttir fyrir bókina
Hratt og bítandi og Sigrún Sigvaldadóttir
fyrir bókina Þrjár sögur eftir Saki.

Bréfagögn og bæklingar: Halla Helgadóttir
fyrir bréfsefni og bækling Þjóðmenningar-
hússins og Ólöf B. Garðarsdóttir fyrir
bæklinginn Óðruvísi kaffitár.

Ekki voru veitt verðlaun eða viðurkenningar
í flokki veggspjalda þar sem dómnefndin
taldi að ekki hefðu borist nógu margar
innsendingar sem uppfylltu gæðakröfur
hennar.

Það er stefna stjórnarinnar að Hönnunar-
verðlaun FÍT verði árlegur viðburður í fram-
tíðinni. Það er von okkar að keppnin eigi
eftir að vaxa að umfangi, verða sýnileg úti
í þjóðfélaginu og vekja athygli. Þannig mun
meðvitund um grafíska hönnun aukast og
skilningur á mikilvægi góðrar hönnunar batna.
Enda er tilgangurinn með Hönnunarverð-
launum FÍT að draga fram, sýna og verðlauna
bestu og athyglisverðustu verk grafískrar
hönnuða og félaga í FÍT um leið og vakin er
athygli á mikilvægi góðrar hönnunar og
stuðlað að brautargengi nýrra hugmynda.

Að lokum er rétt að þakka Svansprenti fyrir
stuðninginn. „Svanavatnið" sem gestir
dreyptu á eftir afhendinguna rann ljúflega
niður.

p.s. Þau sem sendu inn verk í keppnina og
eru ekki búin að sækja þau, eru vinsamlegast
beðin um að gera það sem fyrst. Það er ekki
pláss til að geyma þetta og þann 1. júlí fara
ósóttar innsendingar, því miður, í ruslið.

Design Petter Ringbom Sweden & America Spreads from Swedish–American magazine
Tsia Carson
Doug Lloyd

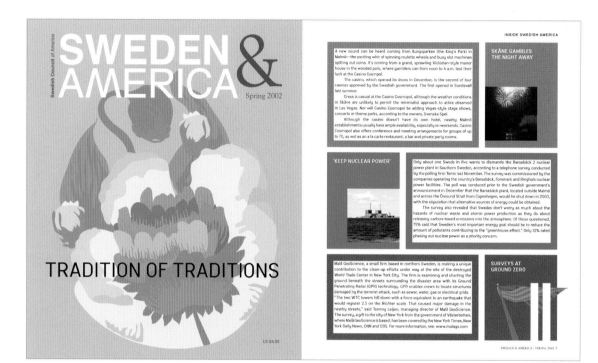

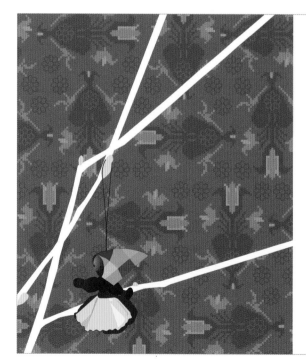

| **Design** | Markus Moström | Angles Suedois Poster | Part of design programme developed for the architects Claesson Koivisto Rune |

ANGLES SUEDOIS

MÅRTEN CLAESSON EERO KOIVISTO OLA RUNE

SAINT-ETIENNE PARIS LUXEMBOURG NICE ATHÈNE CAEN STOCKHOLM

MARKUS MOSTRÖM DESIGN

CLAESSON KOIVISTO RUNE SWEDEN 1997 – 2002

Design Markus Moström Promotional Book Part of design programme developed for the architects Claesson Koivisto Rune

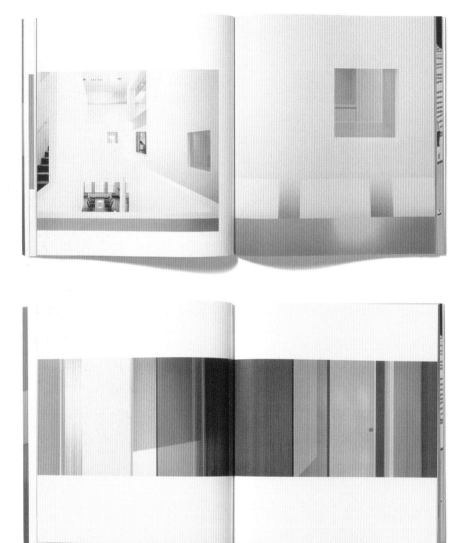

Design Anders Malmströmer När Oskulder Kysser Book jacket designs for Swedish writer Per Hagman
Skugglegender
Match

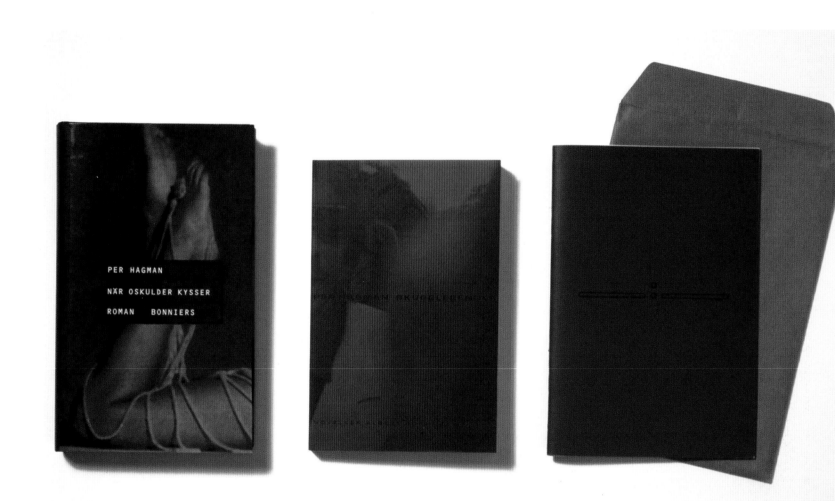

Acknowledgements

55° North
Contemporary Scandinavian Graphic Design

A Supershapes Book Project

Designed and Edited by
Patrick Sundqvist

Introduction by
Patrick Burgoyne

The introduction is based on the thoughts of Patrick Sundqvist as well as ideas received through e-mail exchanges with other Scandinavian graphic designers.

Page Pattern Designs by
Begitte Lynge Andersen from 8bitsandpieces.com

This book could not have been realized without the help of numerous people. Many thanks to all the designers I talked to who gave me greater insight into Scandinavian graphic design and guided me to other designers who I did not know when starting the project. I am grateful to all the designers who took time to answer the questions I frequently distributed vie e-mail. Sometimes these surveys were extensive and took several hours to answer, but regardless, many designers still replied. Everyone I met was willing to share their thoughts, while simultaneously showing a great passion for the craft.

K10k, Surfstation, Newstoday and THREEOH were of great help in my research. Without the numerous e-mails I received from designers all over the world through postings on these sites, suggesting designers they considered great, the selection possibilities would have been greatly reduced.

I also want to thank everyone who supported me, in all possible ways, while creating this book. There is not space here to list everyone, but a few deserving special mention include: Miles & Marvin, Marc and Larry at Magma, The former Vir2L Crew, Toke Nygaard, Ricky Tillblad, Henrikk Karlsson, Dag Henning Brandsaeter, Dennis Eriksson, Simon Tobias, Gudmundur Oddur Magnusson, Oscar Bjarnason, Egill Hardar, Halvor Bodin, Kim Hiorthøy, Marie-Louise Bowallius, James Widegren, Jens Karlsson, Claus Kristensen, Mattias Ollinen, Peter Granström, Joakim Kempff, Nic Cowper, Miika Saksi, Kim Granlund, and my professors at Northeastern University in Boston, USA.

Thanks to Jo, Felicity and Kerstin at Laurence King.

This book is deidcated to Michelle Chen, Birgitta and Åke Sundkvist.

INDEX